Art in Context

Manet : Olympia

Art in Context

Edited by John Fleming and Hugh Honour

Each volume in this series discusses a famous painting or sculpture as both image and idea in its context – whether stylistic, technical, literary, psychological, religious, social or political. In what circumstances was it conceived and created? What did the artist hope to achieve? What means did he employ, subconscious or conscious? Did he succeed? Or how far did he succeed? His preparatory drawings and sketches often allow us some insight into the creative process and other artists' renderings of the same or similar themes help us to understand his problems and ambitions. Technique and his handling of the medium are fascinating to watch close up. And the work's impact on contemporaries and its influence on other artists can illuminate its meaning for us today.

By focusing on these outstanding paintings and sculptures our understanding of the artist and the world in which he lived is sharpened. But since all great works of art are unique and every one presents individual problems of understanding and appreciation, the authors of these volumes emphasize whichever aspects seem most relevant. And many great masterpieces, too often and too easily accepted and dismissed because they have become familiar, are shown to contain further and deeper layers of meaning for us.

Art in Context

Edouard Manet was born in Paris on 23 January 1832, the oldest of three sons of a high government official and a French diplomat's daughter. After overcoming parental resistance to an artistic career, he entered the studio of Thomas Couture, where he remained for six years. His Spanish Singer *was well received at the Salon of 1861, but his later works, including the notorious* Déjeuner sur l'herbe *in 1863, the* Christ Mocked *in 1865, and* The Balcony *in 1869, were either refused or poorly hung by juries and ridiculed by critics and the public. He was, however, defended by Baudelaire and above all by Zola, and eventually he gained some popular success, notably with* Le Bon Bock *in 1873 and* Nana *in 1877. Meanwhile his art had evolved from a tense, ambivalent modernism, haunted by memories of the old masters, to a freer, more naturalistic style, partly influenced by Impressionism. Both tendencies were synthesized in his last major work,* The Bar of the Folies-Bergère *of 1881. Two years later the locomotor ataxia afflicting him grew worse, and he died in Paris on 20 April 1883.*

Olympia, painted in oil on canvas (130 x 190 cm.), was begun in 1862 and completed the following year, but was first exhibited at the Salon of 1865. The delay did not forestall a reaction of unprecedented hostility, and the picture long remained a notorious symbol of modernism. However, in 1890 it was bought from Manet's widow through a public subscription organized by Monet and was offered to the Louvre, where it now hangs. There are several preparatory sketches and a watercolor for it, as well as etchings after it that Manet made to illustrate Zola's pamphlet on him.

The Viking Press New York

Manet: Olympia

Theodore Reff

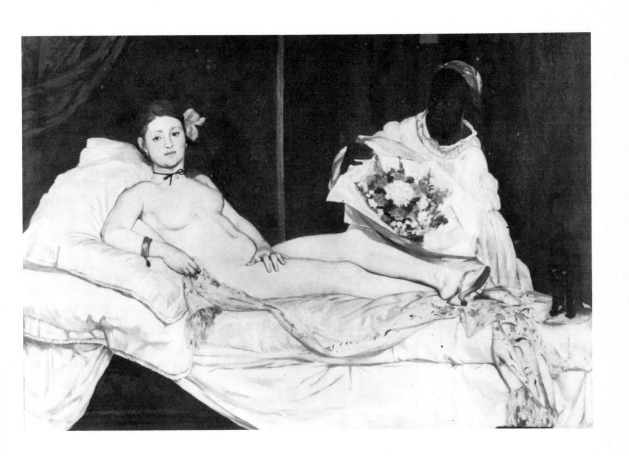

Copyright 1976 in all countries of the International Copyright Union by Theodore Reff
All rights reserved
Published in 1977 by The Viking Press, Inc.
625 Madison Avenue, New York, N.Y. 10022

Filmset in Monophoto Ehrhardt by Filmtype Services Limited, Scarborough
Printed and bound in Great Britain by Butler & Tanner Ltd, Frome and London
Designed by Gerald Cinamon

Library of Congress Cataloging in Publication Data

Reff, Theodore.

Manet: Olympia.

Bibliography: p.
Includes index.
1. Manet, Edouard, 1832–1883. Olympia. I. Title.
ND553.M3R23 759.4 75-42149
ISBN 0-670-45408-7

To my Mother and Father

Reference color plate at end of book

Acknowledgements

It is the fascination that *Olympia* has held for Cézanne, Gauguin, the young Picasso, and many other artists of the past hundred years that first led me to investigate the sources and meaning of its striking imagery and pictorial structure. The results, published a decade ago in the *Gazette des Beaux-Arts*, contained in summary form some of the ideas that are developed more thoroughly in this book. In writing then, as in rewriting now in this much more ample form, I have relied on the two works that, more than any others, have marked a new phase in the history of Manet scholarship, those of George Hamilton and Nils Sandblad. I have also made use, thanks to the cooperation of Hélène Adhémar, of the extensive files on Manet and his works in the Musée de l'Impressionnisme and, thanks to the equally generous assistance of Jean Adhémar, of the valuable collections in the Cabinet des Estampes. In England my work was greatly facilitated by the unique resources of the Witt Library and the Warburg Institute Library and their staffs. For help on this side of the Atlantic, I am indebted to Beatrice Farwell, Associate Professor of Art History at the University of California, to Robert Sobieszek, Associate Curator of the International Museum of Photography, and to two former students, Laura Rosenstock, who gave a fine seminar report on *Olympia*, and Kenneth Bendiner, who served most ably as a research assistant. Finally, it is a pleasure to acknowledge the generosity of the John Simon Guggenheim Memorial Foundation, the American Council of Learned Societies, and the American Philosophical Society for grants which, although officially awarded for other studies, provided opportunities for some searching, unofficial looks at the social and artistic milieu of *Olympia* and at the lady herself.

New York, November 1974

Historical Table

1859	War of France and Piedmont against Austria.
1860	French annexation of Savoy and Nice. Political powers of French legislature extended.
1861	French expedition to Mexico. Financial powers of French legislature extended.
1862	French annexation of Cochin-China. Treaty of Saigon between France and Annam.
1863	French protectorate over Cambodia established.
1864	Pope Pius IX issues Syllabus of Errors, partly attacking French policies.
1865	U.S. demands recall of French troops from Mexico.
1866	Prussia defeats Austria at Sadow, concludes secret military alliances against France.
1867	French troops leave Mexico; defeat and execution of Emperor Maximilian.
1868	Liberal press laws passed in France. Limited rights of public meeting granted.

Salon: Millet's *The Angelus*; Manet's *Absinthe Drinker* and Whistler's *At the Piano* rejected. Degas' *Bellelli Family* begun.	Baudelaire's *Salon de 1859*. Gautier's *Voyage en Espagne*. Hugo's *La Légende des Siècles*. Gounod's *Faust*.	1859
Manet's *Fishing at St-Ouen*. Degas' *Young Spartans Exercising*. Whistler's *Music Room*.	Baudelaire's *Les Paradis artificiels*. E. and J. de Goncourt's *Charles Demailly*.	1860
Salon: Manet's *Spanish Singer* and portrait of his parents. Degas' *Semiramis Founding Babylon*. Delacroix's St-Sulpice murals.	Baudelaire's *Fleurs du Mal*, 2nd edition. Wagner's *Tannhäuser* performed in Paris. Garnier begins Opera House.	1861
Manet's *Music in the Tuileries* and *Portfolio of Eight Etchings*. Degas' first racetrack pictures. Courbet's *Reclining Nude*.	Flaubert's *Salammbô*. Hugo's *Les Misérables*. Leconte de Lisle's *Poèmes barbares*. Mme de Soye's shop of Japanese art opens.	1862
Salon: Cabanel's *Birth of Venus* and Baudry's *The Woman and the Pearl*. Salon des Refusés: Whistler's *White Girl* and Manet's *Déjeuner sur l'herbe*. Death of Delacroix.	Baudelaire's *Peintre de la vie moderne*. Taine's *Histoire de la littérature anglaise*. Renan's *Vie de Jésus*. Berlioz' *Les Troyens*.	1863
Salon: Manet's *Christ with Angels* and *Incident in a Bull Ring*, Corot's *Souvenir of Mortefontaine*; Rodin's *Man with a Broken Nose* rejected.	E. and J. de Goncourt's *Renée Mauperin*. Michelet's *Bible de l'humanité*. Offenbach's *La Belle Hélène*. Gounod's *Mireille*.	1864
Salon: Manet's *Olympia* (painted 1863) and *Christ Scourged*, Degas' *War Scene in the Middle Ages*. Monet's *Déjeuner sur l'herbe*.	E. and J. de Goncourt's *Germinie Lacerteux*. Taine's *Philosophie de l'art*. Proudhon's *Du Principe de l'art*. Meyerbeer's *L'Africaine*.	1865
Salon: Courbet's *Woman with a Parrot*, Degas' *Fallen Jockey*; Manet's *Fifer* and *Tragic Actor* rejected and shown privately.	Baudelaire's *Les Epaves*. Zola's *Mon Salon*. Offenbach's *La Vie Parisienne*. Verlaine's *Poèmes saturniens*.	1866
Manet and Courbet hold private exhibitions outside World's Fair. Manet's *Execution of Maximilian*. Salon: Fantin-Latour's portrait of Manet. Death of Ingres.	World's Fair held in Paris. Zola's pamphlet on Manet and *Thérèse Raquin*. E. and J. de Goncourt's *Manette Salomon*. Gounod's *Roméo et Juliette*. Death of Baudelaire.	1867
Salon: Manet's portrait of Zola, Degas' *Mlle Fiocre*. Monet's *The River at Argenteuil*.	Baudelaire's *Curiosités esthétiques*. Zola's *Madeleine Férat*. Champfleury's *Les Chats*.	1868

1. Critical and Artistic Responses

The violence of the popular reaction to Manet's _Olympia_ [see color plate at end of book] when it was first shown at the Salon of 1865, although discussed many times since then, remains a source of amazement to this day. Now hung in a place of honor in one of the most important museums of Paris, _Olympia_ reigns over the famous Impressionist and Post-Impressionist pictures around it with the authority of a venerated icon. At the time it provoked a hostility without precedent even in the troubled history of nineteenth-century art.[1] Drawn by rumors and newspaper reports, crowds gathered about it as at a public execution or a morgue, horrified yet fascinated. Some found relief in a nervous laughter that spread irresistibly, growing more raucous and ominous; others, offended by what they considered an affront to public morality, threatened physical violence, forcing the Salon officials to station guards before the offensive object. Eventually it was rehung in a remote gallery and placed so high that, as one critic remarked, 'you scarcely knew whether you were looking at a parcel of nude flesh or a bundle of laundry'.[2] Although protected there from the public's aggression, it remained vulnerable to that of the press.

From the beginning caricaturists had seized on _Olympia_ as the sensation of that year's Salon, sensing scandal in the striking nakedness of the nude and irreverence in the Negress and black cat. Insistently, draughtsmen such as Bertall and Cham dwelled on the supposedly vulgar and grotesque aspects [e.g., 1],[3] exaggerating the model's stiffness and slender proportions, turning the maid's

1. Caricature of *Olympia*.
Cham, 1865

2. Satire on Manet, Courbet, and Whistler.
André Gill, 1868

smile into a sensual leer, ridiculing the bouquet wrapped in newspaper, and painting the cat as a diabolical, sexually aggressive creature. Long after the Salon had closed, the animal's inky silhouette, its raised tail unmistakably phallic, continued to appear in caricatures of Manet's art, as in one of 1868 by Gill [2],[4] where it was combined with such rival emblems of notoriety as 'Courbet's parrot' and 'Whistler's little girl'. Not to be outdone, journalists too heaped scorn on *Olympia*, singling out the same elements for sarcastic comment or gleefully describing the public's hostility. Typical of the many expressions of their mockery and bewilderment is Fillonneau's in the *Moniteur des arts:* 'An epidemic of crazy laughter prevails . . . before the canvases by Manet . . . Olympia is a nude, recumbent woman to whom some sort of Negress offers a bouquet voluminously wrapped in paper. At the foot of the bed crouches a black cat, its hair on end, who probably doesn't like flowers since it

cuts such a pathetic figure. Moreover, the heroine herself seems indifferent to the homage of the Negress. Is Olympia waiting for her bath or for the laundress?'[5] Summarizing the virtually unrelieved hostility of this criticism for Baudelaire, who was then in Brussels, Champfleury described the artist's fate in a striking simile: 'Like a man who falls in the snow, Manet has made a hole in public opinion.'[6]

Two explanations have been offered for this unprecedented phenomenon, one based on the mentality of the audience, the other on the content of the picture. According to the first, put forward by Duret, who was one of Manet's earliest supporters, after the Exposition Universelle of 1855 had drawn art exhibitions to the attention of the masses, and the motley Salon des Refusés of 1863 had shown them that contemporary art could be entertaining, a new kind of public flocked to the annual Salons, far more numerous but less cultured than the restricted, largely professional ones of the past.[7] Actually, Courbet's early work had already been greeted with incomprehension and derision by such a popular audience in the 1850s, but it undoubtedly had grown in size and aggressiveness by the following decade, as Zola's devastating account of the Salon des Refusés in his novel *L'Oeuvre* makes clear. The inability of this public to come to terms with works like *Olympia* is precisely what Daumier satirized in his lithograph *Before the Painting of M. Manet* [3].[8] The very image of dull bewilderment, it hardly needed the exchange in its caption – 'Why the devil is that big red woman *en chemise* called Olympia?' 'But, my friend, it may be the cat that's called that' – to make its point.

To such an audience, any work unfamiliar in subject or style would appear baffling. What provoked its reaction in the case of *Olympia* was the uncompromising realism of the situation Manet presented it with. As George Hamilton observes, the figure was 'obviously naked rather than conventionally nude' and 'her wide eyes, imperturbable expression, and impertinent attitude seemed . . . to force the spectator to assume that he was in the same room with her. No conventional generalizations of face or figure mitigated the

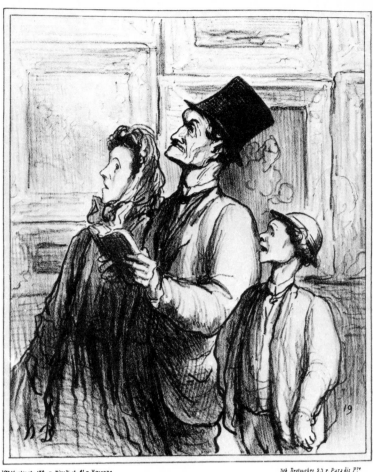

3. Before the Painting of M. Manet
Daumier, 1865

M⁰ˢ Martinet, 172 , r. Rivoli et 41, r. Vivienne Iith Destouches, 23 r. Paradis Pⁱˢ

DEVANT LE TABLEAU DE M. MANET

_ Pourquoi diable cette grosse femme rouge et en chemise s'appelle-t-elle Olympia
_ Mais mon ami c'est peut être la chatte noire qui s'appelle comme ça ?

disconcerting surprise of seeing a modern young woman in a situation few ladies and gentlemen could publicly acknowledge.'[9] Even the most sensual of contemporary Salon paintings did not pose such a threat; for as Mina Curtiss points out, 'Bouguereau's fleshy, rotund nymphs, fleeing half-heartedly from satyrs, exotic odalisques in harems . . . raised no questions of morality, offered no threat to the existing social hierarchy. But a family man, whether accompanied by his wife, his children, or his mistress, was inevitably

embarrassed by Olympia's bold acceptance of her own nudity, by the challenge of her impertinent little face.'[10]

Nor were the professional critics, on whom the public normally relied for its opinions, very helpful in interpreting the challenging subject-matter of Manet's picture. Of the thirty or so whose reviews have been resurrected, none grasped even the most explicit of its allusions to well-known themes in art and literature, to familiar types in contemporary society – to precisely those features, in other words, that give *Olympia* its distinctive meaning and that Manet might have assumed a sophisticated audience would recognize. Several critics, including such distinguished ones as Castagnary, du Camp, and Mantz, ignored it entirely. Others condemned it as unworthy of discussion, Clément declaring in the prestigious *Journal des débats* that it was 'beyond words', and Saint-Victor repeating in the more popular *La Presse* that 'Art sunk so low doesn't even deserve reproach'.[11] Those who did disdain to comment either professed not to understand or concentrated on formal issues; either demanded peevishly, like Claretie, 'What is this Odalisque with a yellow stomach, a base model picked up I know not where, who represents Olympia? Olympia? What Olympia?'[12] or asserted categorically, like Gautier, 'The color of the flesh is dirty, the modeling non-existent. The shadows are indicated by more or less large smears of blacking ... The least beautiful woman has bones, muscles, skin, and some sort of color. Here there is nothing ...'[13] Even the relatively few critics who admired the picture avoided its controversial imagery and instead defended it in purely formal terms. 'Solid and painterly qualities predominate in it,' wrote Privat. 'The young girl is done in a flat tone, her flesh is of an exquisite delicacy, a nicety, in a perfect relationship with the white draperies.'[14] And her frequently ridiculed companions and attributes, 'her magnificent bouquet, her Negress, and her black cat', added Thoré, were beautifully painted.[15] Yet all this said nothing pertinent about their meaning or about that of Olympia herself for Manet's contemporaries.

Thoré and his colleagues were no doubt prevented from recognizing such meanings by the tacit yet widely observed conventions, both formal and ethical, of mid-nineteenth-century Salon criticism.[16] But this does not explain why some of the same critics, operating within the same conventions, had understood without difficulty the social implications and art-historical allusions of *The Romans of the*

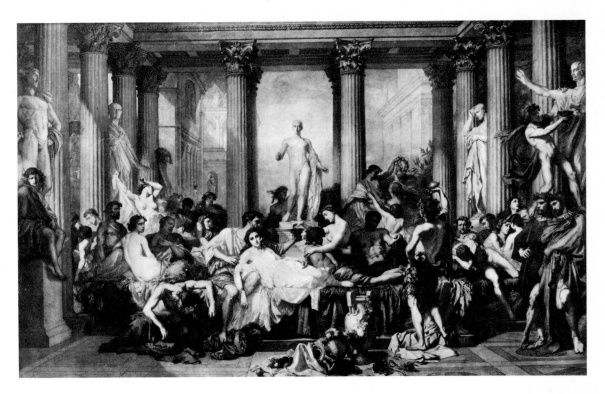

4. *The Romans of the Decadence*, Thomas Couture, 1847

Decadence [4], a picture with essentially the same theme as *Olympia* exhibited almost twenty years earlier by Manet's teacher Couture. Gautier and Saint-Victor had spoken eloquently of the recumbent courtesan in the center [5] as 'a figure that contains in herself all the symbolism of the composition . . . a pagan Venus, drunk with the joys of her carnal divinity',[17] yet they could not see that Olympia, who assumes the same position facing the spectator and is even more explicitly reminiscent of a pagan Venus, might have the same or

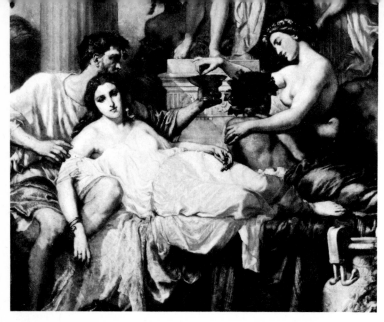

5. *The Romans of the Decadence*, detail

indeed any significance. Both writers had also noted with admiration that the overall design, architectural setting, and coloristic style of Couture's work were inspired by Venetian art, specifically by Veronese's *Marriage at Cana*,[18] yet they could not see that *Olympia* bore an even closer resemblance to Titian's *Venus of Urbino*; and if they could, they would surely have accused Manet of plagiarism. Nor did any of their colleagues make the connection – not even Thoré, who had raised the issue of plagiarism the year before and now announced that Manet's other entry in the Salon of 1865, the *Christ Scourged*, was 'almost a copy of the famous composition by Van Dyck'.[19]

In the same way, both Saint-Victor and Zola refused to take the subject-matter of *Olympia* seriously, the one convinced that it was immoral, hence beneath his dignity, the other that it was without meaning, hence irrelevant to his purpose. Yet in these years both writers were outspoken in lamenting the prominence in French society of precisely the type that Manet depicts in *Olympia*, the wealthy courtesan who was then at the height of her power and notoriety. 'In which age', asked Saint-Victor in 1871, 'had one ever seen them attract the attention and gain the position that they had usurped in the recent past? They filled up novels, took over the stage, reigned at the Bois [de Boulogne], at the racetracks, the

theater, wherever crowds gathered.'[20] And Zola, who was already planning *Nana* as a monumental study of the life of a Second Empire courtesan, warned his countrymen in 1868, two years before Sedan, that an age like theirs, in which vice 'openly displays itself, . . . always heralds some social crisis. When termites attack a society, that society soon crumbles into dust, like an old structure riddled with imperceptible holes.'[21]

*

Ironically, it was Zola who was most effective in diverting attention from the imagery and meaning of *Olympia* to its form and style. To what extent he was reflecting the artist's intention is difficult to say. When his article on Manet appeared in *L'Evénement* in May 1866, the two men were barely acquainted. Zola had of course been a close friend of Cézanne's for many years and, perhaps guided by him, had written occasionally on art, but without attracting any attention. Now, as part of his ambitious plan to establish a reputation in journalism as well as fiction, he became almost overnight a champion of advanced art, a courageous defender of Manet and others in the Realist movement; and as a result he soon gained a much greater renown and soon lost his job on *L'Evénement*. In this first article,[22] written in a frankly polemical tone within a year of the scandal over *Olympia*, Zola sought to defend the work by exposing the hypocrisy of those who had ridiculed it. He described the figure as 'she who has the serious fault of closely resembling young ladies of your acquaintance. There, isn't that so? What a strange madness not to paint like the others! If, at the least, Manet had borrowed Cabanel's powder puff and powdered Olympia's face and breasts a bit, the young lady would have been presentable . . .' And he mocked the many viewers who had professed to be shocked by the presence of a cat: 'A cat, imagine that. A black cat, moreover. It is very amusing . . . O my poor fellow-citizens, admit that you have frivolous minds.' Grateful for this support, Manet wrote immediately to arrange a meeting with Zola 'in order to shake your hand

and to tell you how happy I am to be defended by a man of your talent'.[23] But it is obvious from his admission 'I do not know where to find you' and his proposal to meet at the Café de Bade that this was merely the beginning of their friendship.

It was only in the latter half of 1866, at the less fashionable Café Guerbois in Montmartre, where Manet and his literary and artistic friends began to gather regularly, that Zola really became familiar with their work and aesthetic ideas. Thus in a revised and enlarged version of his article on Manet, published in January 1867[24] and in pamphlet form five months later, he could write far more perceptively about the pictorial character of *Olympia*. Correctly, he noted that the distribution of lights and darks is such that 'at first glance you distinguish only two tones in the painting, two strong tones played off against each other', and that the objects are rendered in relatively little detail, 'in simple masses and large areas of light', giving the whole a 'somewhat rude and austere appearance'. And very astutely, he observed how 'exquisitely refined [are] the pale tones of the white linen on which Olympia reclines. In the juxtaposition of these various whites an immense difficulty has been overcome.' The contrast with his previous discussion of *Olympia* makes it clear how much Zola had learned at the Café Guerbois in the months between.

He had however not abandoned his polemical attitude, but merely refined it; for this discussion too had a tactical goal. Although convinced that *Olympia* was Manet's masterpiece, 'truly the painter's flesh and blood', Zola had no illusion that his readers shared his opinion; on the contrary, he knew that many who saw it at the Salon 'would not have been displeased to find an indecent intention'. Rather than attempt to answer this charge by analyzing the picture's subject-matter, he employed a bolder tactic: he denied there was a content to begin with, thus shifting attention to purely formal issues. 'Tell them aloud, then, *cher maître*, that a painting is for you a mere pretext for analysis. You needed a nude woman, and you chose Olympia, the first to come along; you needed clear and luminous

tones, and you introduced a bouquet; you needed black tones, and you placed in a corner a Negress and a cat. What does all that mean? You hardly know, and neither do I.' Apart from its tactical purpose, this approach reflects Zola's conception of the artist as a naturalistic observer who, like himself, renders the objects he perceives acutely and energetically but without concern for their social or personal significance.[25] It would be pointless even to search for a meaning, since Manet, 'a child of our times . . . an analytical painter . . . has never committed the folly, as did so many others, of wishing to put ideas into his painting'. In alluding to the aesthetics of Romanticism, which he himself had rejected only a few years earlier, Zola revealed the importance of this article for his own development in the 1860s, a shift from Romanticism to Naturalism in which precisely this devaluation of subject-matter was the principal issue.

It is evident now that the position Zola adopted as an art critic prevented him from recognizing the relevance of *Olympia* to social phenomena of which he was keenly aware as a journalist and novelist. His newspaper chronicles and book reviews in the last years of the Empire are filled with indignant or sarcastic remarks on 'the gilded folly, the insolent filth of these women . . . the craving for luxury, the life of excesses, the frenzy of all the appetites, [which] have soiled and brought down the most proud'.[26] In the same years he published *Madeleine Férat*, a melodramatic story of illicit love painted, like *Olympia*, in stark tones of black and white, and projected as part of the Rougon-Macquart series a full-length portrait of Nana, the very type of the *grande cocotte*. It has in fact been argued that the cold yet sensual expression of Madeleine owed something to Olympia's and that the image of Nana as a goddess or idol of prostitution was indirectly inspired by it.[27]

Whether Zola was also stating Manet's views in stressing the primacy of form rather than content is difficult to know. The latter's response – 'You have given me a first-rate New Year's present, your remarkable article pleases me very much'[28] – was grateful but noncommittal. Too tactful to express a reservation, he may nevertheless

have felt about Zola as he did about later critics who defended him but whom he sensed did not 'penetrate very well into everything there is in me or at least everything I try to reveal'. Citing an anonymous example, he explained that, despite his disappointment, 'it would be in bad taste for me to upbraid him; impossible to be angry at him'.[29] Zola himself later admitted that he was more interested in proclaiming his own aesthetic than in explaining Manet's, which he did not fully appreciate. 'I was young then', he told a colleague, 'I was looking everywhere for weapons to defend the doctrine on

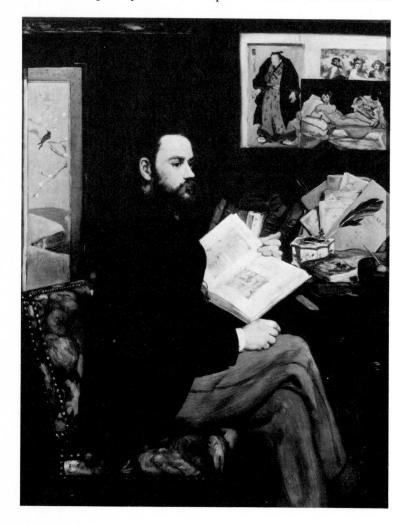

6. *Portrait of Emile Zola*, Manet, 1868

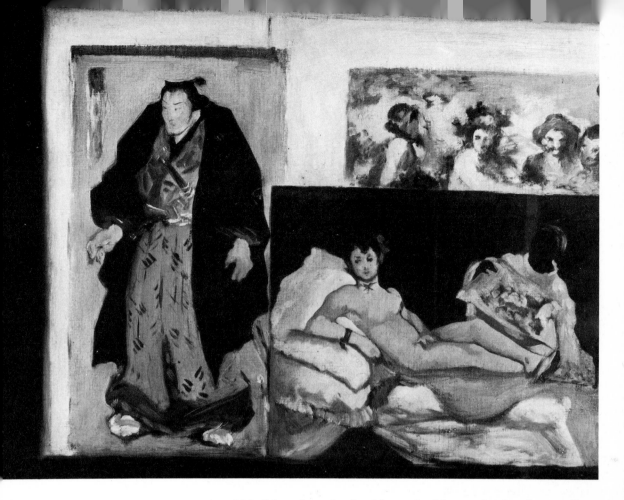

7. Portrait of Emile Zola, detail

which I based my books. Manet, by his care in choosing modern subjects and his search for realism, seemed worth supporting. But to tell the truth, his painting has always disconcerted me a little.'[30] In any event, the sophistication Manet revealed in introducing or deftly modifying certain elements in his portrait of Zola [6], painted in 1868 in return for the latter's public support, makes it clear that the writer had not really understood the artist's subtlety or complexity.

On the desk behind Zola in this portrait,[31] foremost among the books and pamphlets, is a copy of the essay on Manet he had published the previous spring; and clearly inscribed on its bright blue cover are the title and author's name, functioning now in reverse as the portrait's signature and dedication. Moreover, on the wall above Zola's head [7] there is a photograph of *Olympia* itself, flanked

by a Japanese woodcut and a lithograph of Velázquez' *Drinkers*; and whereas in the painting her glance is directed at the spectator, here it is turned toward the writer, thus acknowledging his gallant efforts to defend her reputation. By a similar modification, or by choice of model, Manet has also contrived to have two of the figures in the other works repeat her gesture. The heavy-set wrestler in Kuniaki's woodcut not only looks at but turns his whole hulking presence toward Zola, as if in homage or readiness to serve. And the sleek young Bacchus in *The Drinkers* looks to the left and slightly down, once again toward Zola, as he crowns one of his followers, rather than slightly up as in the lithograph. In juxtaposing the standing wrestler and the recumbent nude – one an image of strength and combativeness, the other of grace and sensuality – Manet was evidently paying a subtle compliment to the subject of his portrait. Nothing in the latter's comments on the picture indicates that he was aware of it.

<p style="text-align:center">*</p>

Whatever its shortcomings, Zola's interpretation of *Olympia* had a great influence on later criticism, not immediately but in the 1920s and 1930s, when it was quoted in support of a formalist view. Thus Rosenthal could assert that those who had seen in the work an image of the modern urban prostitute were altogether wrong: 'To ascribe such intentions to Manet is to misjudge his mind entirely . . . Zola testifies as much, who was his defender and, in large measures no doubt, the interpreter of his thought.'[32] Jamot too could maintain that *Olympia* is 'the creation of a great painter with a frank and healthy outlook . . . actuated by purely pictorial considerations' and cite as proof 'the testimony of Zola which, dating from 1867, was not written without the consent of Manet himself'.[33] That this interpretation did not prevail before the 1920s we shall see presently. That its emergence then coincided with Purist and Neoclassical tendencies in post-War art is evident from the comments on *Olympia* by Waldmann and Severini, among others. For the former, 'the

picture contains nothing indecent, nothing at all piquant or per-
fumed'; rather it is cool, remote, austere.[34] For Severini, whose
own art had turned from Cubist to Neoclassical, Manet's was a
purely pictorial achievement, admirable in its use of light and dark
tones to create luminosity and of warm and cool ones to suggest
modeling.[35]

These themes continued to dominate the literature on *Olympia*
for the next thirty years. Thus Rey, though he felt 'the malevolence
of her gaze, so terribly alive', admired most the delicacy of a coloring
so subtle that 'in the folds of the sheet alone the harmony of the grey
tones is without end'.[36] And Florisoone, raising pictorial refinement
to the level of a cult, maintained that the nude was 'modeled with a
delicacy and a respect which remove it from any vulgar thought:
this flesh and skin, washed of their habitual imperfections, are as
it were idealized in their very substance'.[37] Nor were other once
controversial features still found provocative: in his short mono-
graph on the picture Mathey blandly concluded, 'If Manet put
nothing into [the model's] gaze, it is because it expressed nothing.
One painted and the other posed. Conscientiously. Simply. As for
the malevolent cat, it is nothing but a gratuitous fantasy . . .'[38]
Indeed the extent to which he supposedly suppressed subject-matter
in order to 'obtain a plastic-chromatic coherence of his own' now
became the key to Manet's achievement: 'With the *Olympia*',
declared Venturi, 'he introduced the principle of the autonomy of
vision into art, and all modern art has used it as a basis and as a
banner.'[39] Asserting this view in opposition to that of Valéry, who
alone had spoken in the 1930s of 'the cold and naked Olympia, that
monster of banal sensuality', Bataille stated flatly that the picture
'is meaningful only to the extent that Manet . . . flushed out of it the
literal sense Valéry read into it'.[40]

This interpretation, we have seen, originated in Zola's essay of
1867, partly as a defense against hostile criticism. When he reiterated
it nearly twenty years later, in his preface to the catalogue of the
Manet memorial exhibition,[41] its impact on that criticism was

already noticeable. Thus the academician Gonse, while continuing to deplore 'the strangeness of the composition, the improbability of certain details', acknowledged that the Negress is 'an excellent piece of painting' and that the scale of tones is 'of a superior quality'.[42] But Zola's disciples in the Naturalist movement were now prepared to go further. Huysmans, struck by the mystery and expressive vitality of the work, noted that 'the head stares with an irritating enigma; it's alive, superb . . . Goya transposed by Baudelaire; vivid face, breasts; his true masterpiece . . .'[43] And Geffroy, a writer more concerned with the social significance of art, stated explicitly: 'Olympia is a Parisian prostitute, the first who has appeared thus in the painting of our time . . . [Manet] has created a woman who embodies the habits of a city, the appearance of a class.'[44] Zola's position was however affirmed a decade later by Duret, who explained the public's hostility as a product of ignorance and prejudice and added: 'When one looks at [*Olympia*] today, one finds it as chaste as any mythological nymph.'[45] But it was rejected, at least implicitly, by Proust, another of the artist's early friends, who regretted that the public, 'which has a preconceived idea of the courtesan as an opulent woman . . . [with] the abundant charms of a Jordaens model', failed to see that her true image 'is just as much in that impoverished nudity which Manet has represented'.[46] Although other writers began now to focus more attention on *Olympia*'s artistic sources, Meier-Graefe in particular analyzing its relation to the recumbent Venuses of Titian and Velázquez and the notorious *Majas* of Goya, it was largely in order to define the tense, self-conscious, specifically modern character of Manet's nude.[47] Summing up this awareness in the pre-War literature of the unity of form and content in *Olympia*, Hourticq observed that 'the whole picture of wantonness is rendered in a livid pallor and the hues of morning'.[48]

Returning to this view in reaction against the narrow formalism of the intervening period, but with a fuller understanding of the connections between Manet's art and the culture and society in which

it was created, scholars of the past twenty years have examined the meaning of *Olympia* in terms of nineteenth-century literature and social life as well as art, and within the latter have discovered sources in popular prints and photography as well as high art. Thus Nils Sandblad has redefined in a positive sense what had been seen in the 1930s only as proof of Manet's indifference to subject-matter and lack of imagination, his use of old master pictures as models, though curiously Sandblad denies their importance in the case of *Olympia* itself.[49] John Richardson has discussed its deliberately provocative character as a Salon exhibit and its relation to risqué subjects like Clésinger's *Woman Bitten by a Snake* and allegorical scenes of prostitution like Couture's *Modern Courtesan*.[50] George Hamilton has gone beyond the many older allusions to the Baudelairean qualities of *Olympia*, drawing comparisons between Manet's conception of the coldly enticing woman, her jewelry and jewel-like eyes, her exotic servant and sinister cat, and specific passages in *Les Fleurs du Mal*.[51] In an earlier, much shorter version of the present publication, I indicated how closely *Olympia* is related, as an image of the *grande cocotte* of the Second Empire, to her vogue in the Social Drama of the time and the unstable, extravagant society that she came to epitomize.[52] More recently Gerald Needham has found visual equivalents of her appearance in the theater in contemporary pornographic photographs, a vernacular imagery of the provocative nude figure that is relevant to *Olympia* both in form and content.[53] And Werner Hofmann, in discussing its successor *Nana*, has noted parallels or precedents in other forms of nineteenth-century popular art, in erotic lithographs of the Romantic period and illustrations and novels of the Realist period, thus broadening the cultural context in which the picture can be understood.[54]

*

Some of the most penetrating comments on *Olympia* have been visual rather than verbal; for it is far too challenging in conception,

too brilliant in execution, not to have elicited responses, besides the
caricatures already discussed, from many artists over the last
hundred years. At times their interpretations have coincided in
interesting ways with those of the historians and critics. In 1866, for
example, while the latter were still heaping scorn on Olympia's
flattened and outlined forms, comparing them to crudely rendered
popular woodcuts, Courbet showed at the Salon his *Woman with a*

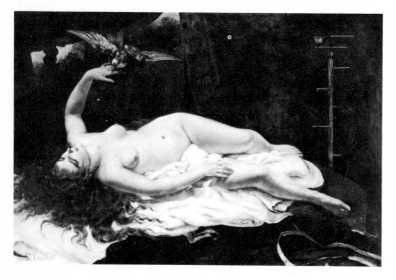

8 (*left*). *Woman with a Parrot*,
Courbet, 1866

9. *Olympia*, Manet, 1867

10. *Olympia*, Manet, 1867

Parrot [8], a voluptuously reclining nude whose 'elaborate pose and
artificial gesture', like her 'sober color scheme and dense modeling',
were 'in a roundabout way a reply to Manet's challenge in *Olym-
pia*'.[55] Courbet was also reported to have said, 'It's flat, it's not
modeled, it's the Queen of Spades stepping out of her bath' – an odd
criticism coming from an artist who admired and drew inspiration
from popular woodcuts. Replying in kind, Manet supposedly
remarked that Courbet's aesthetic ideal was a billiard ball.[56]

The following year he himself reinterpreted *Olympia*, now four
years old, in terms of his current interests. That he chose it as the
subject of two etchings he made to illustrate Zola's pamphlet,[57]
where one was eventually printed, shows how much importance he
attached to it as an epitome of his art and confirms the writer's

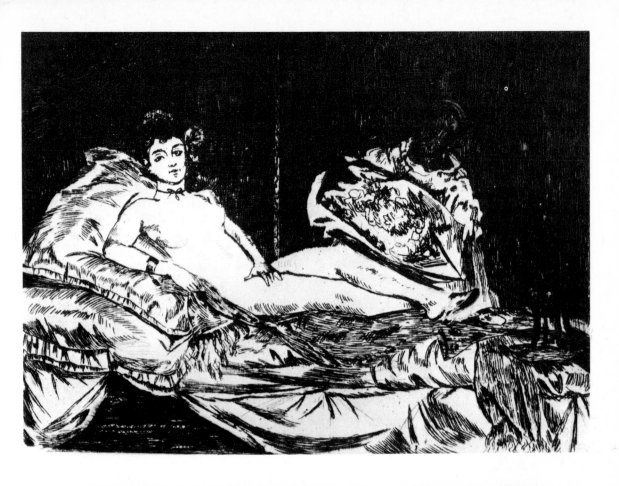

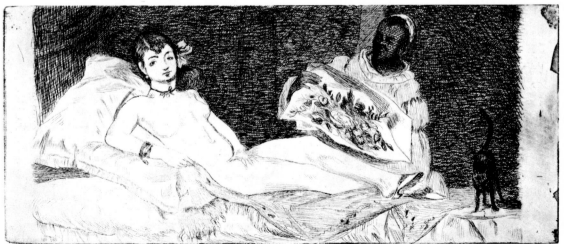

opinion of it as his masterpiece. But that he experimented in one print [9] with a radically simplified tonal structure and in the other [10] with a more restricted format, focusing attention on the principal elements in an even flatter, more emblematic manner, suggests how unconventional his conception of it had become. Also an innovation is the curl on Olympia's forehead, a distinctly Spanish motif reminiscent of Goya's art and perhaps indicative of the role the latter had played initially. The same is true of the small replica that appears, in the guise of a monochromatic photograph, in the background of Manet's portrait of Zola one year later [7]. Here too it serves as an emblem of his achievement and, as we have seen, makes possible a remarkable new achievement.

Also shown at the Salon of 1868 was Lefebvre's *Reclining Woman*, a meticulously painted nude that is vaguely reminiscent of *Olympia* and has been described by Rosenthal and others as an academic response to it.[58] Despite the figure's evident sensuality and seductive gaze, however, it does not resemble Manet's closely enough to be accepted as such; rather, it represents the kind of sleek Salon nude to which his in turn was a response.

Far more explicit in relation to *Olympia*, yet also more personal in expression, are several variations on it painted by Cézanne in the 1870s.[59] In the oldest, ironically entitled *A Modern Olympia* [11], he transformed the dark, enclosed space of the original into a lavishly furnished salon, adding food and drink to heighten the mood of orgy and introducing the male visitor whose presence is only implied there. In a version painted three years later, in the luminous tones and flickering touches of his new Impressionist style, he maintained the same design but modified the action, having the Negress unveil the voluptuous nude before the awestruck visitor's gaze – in the spirit of what Valéry later called the 'ritual animality' of *Olympia*. Still haunted by its provocative imagery, Cézanne returned to Manet's picture several times in the following years [e.g., 12], retaining the major motif of the reclining nude and varying the minor ones of the servant, the visitor, and the cat; but

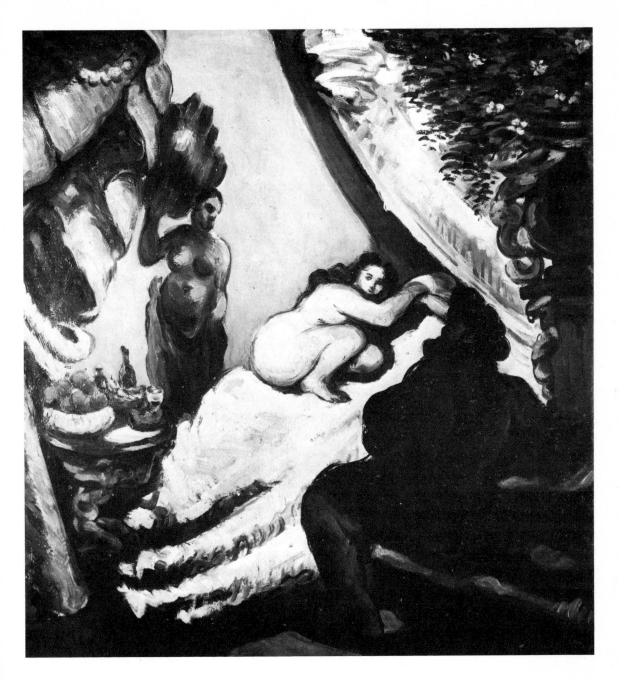

11. *A Modern Olympia*, Cézanne, *c.* 1870

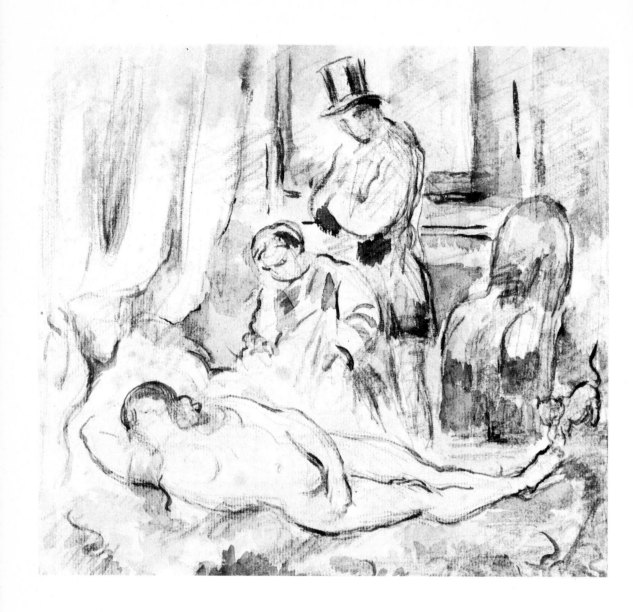

12. *Olympia*, Cézanne, 1875–7

his increased concern with pictorial structure drained these delicate watercolors of their erotic intensity.

How easily the 'animality' of *Olympia* itself could be tamed is shown by Fantin-Latour's copy [13], probably made in 1883 to illustrate a memorial article on Manet.[60] By rounding the figure's head and blurring its features and those of the Negress and cat, thus softening their sharpness and immediacy, and by lightening the background and eliminating strong tonal contrasts, thus weakening the dramatic impact of the whole, Fantin succeeded in idealizing *Olympia* in the manner of an Ingres odalisque. In this he unwittingly indicated one of its principal sources and at the same time anticipated the formalist view of it as a nude in the classical tradition.

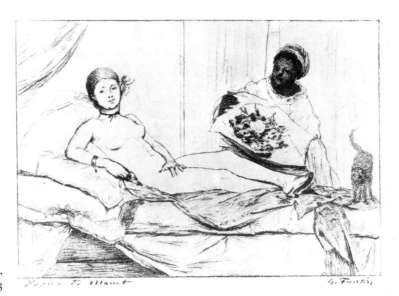

13. Copy after *Olympia*, Fantin-Latour, *c.* 1883

More faithful to the original is the copy Gauguin painted about 1890 [14], soon after it had been purchased by public subscription and installed in the Luxembourg Museum.[61] He had already hung a reproduction of *Olympia*, for which he reportedly had 'a special admiration', in his room in Brittany and had followed the progress of the subscription closely.[62] Hence his carefully executed copy,

36

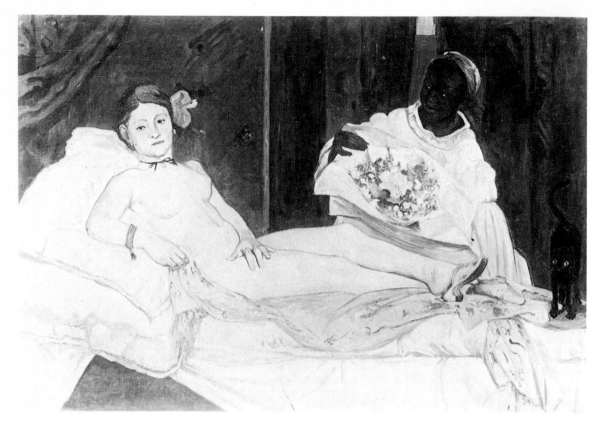

begun in the museum but completed in his studio, was an act of
homage, an acknowledgement of the relevance of Manet's flatly
painted and firmly outlined forms for his own 'synthetist' style.
But it was also a commentary, an adaptation of the original to the
terms of that style, particularly in the greater rhythmic flow of the
contours and the more visible diagonal brushstrokes. Gauguin's
independence of it is far more evident in a notebook caricature that
he drew when *Olympia* was shown at the Exposition Universelle
the year before [15];[63] probably working from memory, and in a
swift, emphatic idiom, he transformed the elegant courtesan into a
common whore. Yet the distinction of Manet's picture continued
to haunt him even in Tahiti many years later, for it was clearly one
source for his *Woman with the Mangoes* of 1896. That the other

14. Copy after *Olympia*
Gauguin, 1890–91

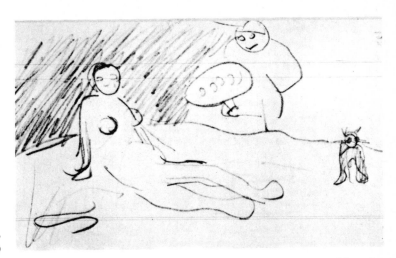

15. Caricature of *Olympia*,
Gauguin, 1889

source was a *Venus* by Cranach suggests that, like the art-historian Muther at the same moment, Gauguin had recognized an affinity between *Olympia* and the German artist's smoothly painted, sexually suggestive nudes.[64]

In the same way, the young Picasso hinted at another, more important Renaissance model for *Olympia*, one that was also being discussed at the time, in a parody he drew in 1901 [16], during his

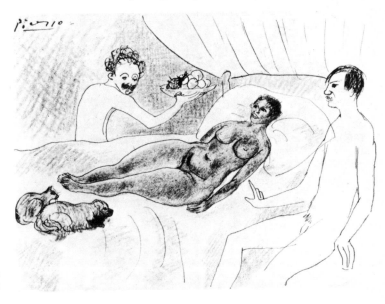

16. Parody of *Olympia*,
Picasso, 1901

first trip to Paris.[65] With characteristic irony he stripped Manet's image of its Parisian elegance, replacing the svelte courtesan with the heavy Negress and the latter with a naked man carrying a bowl of fruit, and placing beside the bed a second man who points ambiguously; this is Picasso himself, while the first is his friend Junyer. By increasing the number of figures – even the cat has a canine companion – and reversing their social status and racial roles, he underlined the latent primitivism of Manet's conception. Moreover, by incorporating elements of Titian's *Venus with the Organplayer*, which he had recently seen in the Prado,[66] Picasso alluded to the Venetian artist's part in the creation of *Olympia*: his black nude recalls in form and position the white one in Titian's picture, just as his friend Junyer staring over his shoulder at her sex recalls the organplayer's stare. That Manet actually relied on another Titian *Venus*, the Uffizi's *Venus of Urbino*, was first noted in the late 1890s and first discussed in detail more than a decade later. In the interim Picasso took up the theme of prostitution in an altogether more original form in the *Demoiselles d'Avignon*; but the fruit bowl shown in some of the studies for it may derive from his earlier parody, just as the naked, brazenly staring figures in the final version may derive from *Olympia* itself.[67]

Unlike the Demoiselles, the many prostitutes in Rouault's paintings of 1905–7 look sadly at the spectator or turn wearily away, burdened by a sense of shame that Picasso's and Manet's creatures do not feel. Yet one of these pictures bears Olympia's name and is clearly a comment on her calculated immorality.[68] Intensely personal, it conveys the artist's obsession with moral degradation both in the dreariness and obesity of the flesh and in the exaggerated coarseness of his depiction of it. The same is true of the heavily outlined nude in an etching Rouault made in 1927 [17], one of a series showing prostitutes which were to illustrate *Les Fleurs du Mal*.[69] But here the resemblance to *Olympia* is evident in the reclining nude's posture too, thus linking it with the recurrent images of carnal temptation in the poems themselves and confirming, as it

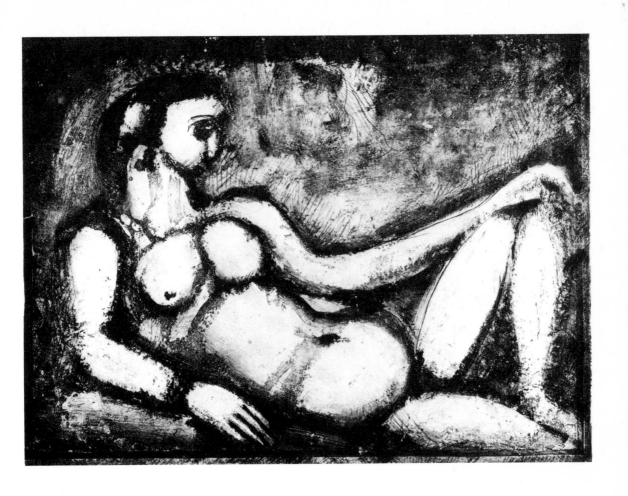

17. *Naked Courtesan*, Rouault, 1927

were, those hints of a link between Baudelaire's conception and
Manet's that were already heard during their lifetime.

The most extreme statement of this Expressionist rejection of
Olympia is undoubtedly Dubuffet's painting of that name [18],
executed in 1950 as part of his 'Corps de Dame' series.[70] The
grossly swollen, repulsive body represents an absolute antithesis of
the slender, seductive one Manet had depicted, just as the deliber-
ately coarse surface, its pigments suggestive of mud or detritus, its

18. *Olympia* (*Corps de Dame*),
Dubuffet, 1950

texture roughened with asphalt and heavily scored with a knife, is
the very antithesis of the subtle color modulations and smooth
application of paint that he had labored to achieve. In a sense
Dubuffet's *Olympia* represents Manet's as it was described by
hostile critics when first exhibited – intentionally crude and defi-
antly ugly – but in a deeper sense it is perhaps the only authentic
image of such a creature that could have emerged in the turmoil of
the post-War years.

In contrast to Rouault's and Dubuffet's interpretations, those of
the last decade have been parodies in the cool, ironic spirit of Pop

Art. In *Site*, a dance piece performed in 1965, Robert Morris, wearing a mask with his own features, removed a large white panel to reveal a nude dancer reclining on a white sheet against a white panel in the same pose as Olympia.[71] A deliberate mockery, it drained Manet's image of its dramatic intensity by replacing its striking black and white design with a chic overall whiteness and converting its provocative revelation of nakedness into a routine display reminiscent of a department store window. Equally iconoclastic is Larry Rivers' satire of 1970, *I Like Olympia in Black Face* [19], a painted

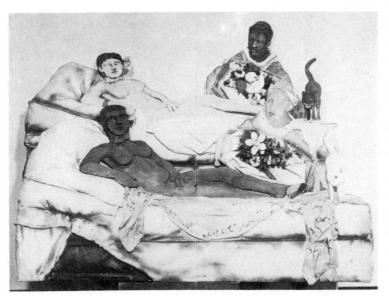

19. *I Like Olympia in Black Face*, Larry Rivers, 1970

plastic construction in which the maid's robe is bright scarlet, her flowers are 'real' artificial ones, etc., and the roles of the races are reversed.[72] The Negress now plays the naked courtesan and the white woman her servant, and the cat too is stark white; but directly below them the three creatures appear in their original colors, as if Rivers were conjuring up the ghost of Manet's work even as he vulgarized it. That it continues to intrigue and provoke artists on both sides of the Atlantic is evident from Mel Ramos' sleek 'girlie magazine' parody and Arthur Ballard's vaguely sinister variation *Punch and His Judy, No. 3,* both painted in 1973.[73]

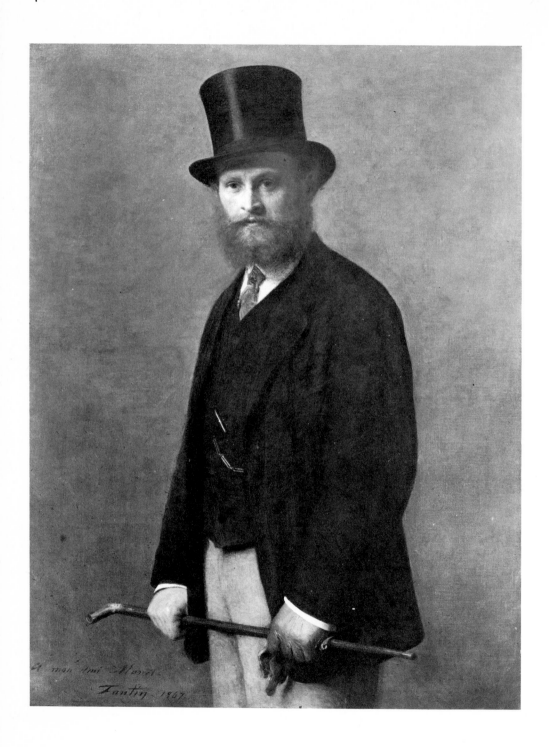

2. Pictorial Sources and Structure

Clearly *Olympia* has become one of the venerable icons of modernism, a work of art so familiar it can be recognized instantly in whatever guise it appears. Despite its notoriety, however, it remains very imperfectly understood. Many questions remain unanswered, even fundamental ones concerning Manet's decision to exhibit it in 1865. If he completed it in the spring or summer of 1863, too late for inclusion in the Salon des Refusés along with the *Déjeuner sur l'herbe*, why did he not show it the following year? And if that was because the popular and critical response to the *Déjeuner* had been negative – almost as negative as the response to *Olympia* itself would be – why did he exhibit the latter at all? What makes such a question difficult to answer is not only the lack of any document from that period which might illuminate Manet's motives or state of mind, but the vague and incomplete picture of his personality which results from the lack of truly revealing documents from any period of his career. Like the detached and debonair figure in Fantin-Latour's portrait of him [20], painted two years after the *Olympia* scandal, he remains the most enigmatic artist of his time.

In the older literature, it was assumed that Manet, 'discouraged and frightened of possible scandal', decided to exhibit *Olympia* only after his wife, 'a good and intelligent woman', or Baudelaire, one of his closest friends, had urged him to.[1] But there is no evidence that Mme Manet ever interfered in her husband's affairs or that the poet ever saw the picture, let alone urged its exhibition (the letter formerly cited as proof of his role implies that he knew the work

only from a verbal description).[2] In the recent literature two quite different explanations have been proposed. One is that Manet, 'a member of a conservative family whose social standards he never repudiated, could justify his artistic career only by a popular success at the Salon' and that *Olympia* was the kind of 'elaborately contrived and intricately executed historical subject' that might have assured such a success.[3] The other is that, while hoping it would be admired as a modern version of a traditional genre, he fully expected it would provoke the public, in keeping with his 'Baudelairean cult of dandyism, his enjoyment of "the pleasure of astounding people combined with the arrogant satisfaction of never being astounded oneself"'.[4] But the first theory fails to explain why, in seeking a success at the Salon, he did not choose a more socially acceptable subject than a naked prostitute, particularly since the *Déjeuner sur l'herbe* had been considered indecent. And the second fails to acknowledge how astounded he himself was by the violent reaction to *Olympia* and how undandyish was the self-pity he expressed in a letter to Baudelaire; in fact the latter had to remind him that he was not 'a greater genius than Chateaubriand or Wagner', who 'certainly were made fun of' yet 'didn't die of it'.[5] Moreover, the only other indications of Manet's attitude at the time, some remarks reported by his friends Proust and Duret many years later, suggest that he had confidence in the directness of his vision and technique – 'I render as simply as possible the things I see. What could be more naïve than *Olympia*?' – and that he was genuinely surprised when his own works were attacked while the Renaissance ones they followed closely were not.[6]

No less puzzling is Manet's decision to present *Olympia* to the public as the 'august young woman' who figures in a long poem written about the picture by his friend Zacharie Astruc, the first stanza of which he inscribed on the frame and printed in the Salon catalogue, as if it were a statement of his intentions:

> Quand, lasse de rêver, Olympia s'éveille,
> Le printemps entre au bras du doux messager noir;

C'est l'esclave, à la nuit amoureuse pareille,
Qui vient fleurir le jour délicieux à voir:
L'auguste jeune fille en qui la flamme veille.[7]

Inevitably it was read as such a statement, though it neither explained nor even described the picture accurately, thus increasing the critics' confusion; as Chesneau put it, 'the comedy is caused by the loudly advertised intention of producing a noble work . . .'[8] Nor was the entire poem, published posthumously in the volume *Les Alhambras*, any more interesting. A tedious imitation of the exoticism of certain love poems in *Les Fleurs du Mal*, it can hardly have impressed Manet, a close friend of Baudelaire and later of Mallarmé, both of whom wrote far more original verse in honor of his pictures. Here too his motives are hard to fathom. Was it a sense of obligation to Astruc, who had been almost alone in defending him energetically in 1863, that led him to acknowledge publicly this ambitious work inspired by his own? Or was he aware of its irrelevance and, acting in the spirit of Baudelaire, who had mocked the obscurity of the titles printed in Salon catalogues,[9] was attempting to ridicule the pretentious literary texts that often accompanied them? Again there is not sufficient evidence to decide; but another aspect of Manet's presentation of *Olympia* to the public suggests that he hoped to appease rather than antagonize it.

*

Together with *Olympia* Manet exhibited his *Christ Scourged* [21], a picture altogether different in theme, as if to demonstrate his skill in handling the male as well as the female nude, the traditional as well as the modern subject.[10] At the previous Salon too he had paired sacred and profane images, this time of death, in showing the *Incident in a Bull Ring* and the *Dead Christ with Angels*,[11] though this did not prevent their being criticized severely on other grounds. In the case of *Olympia* and *Christ Scourged*, however, his gesture may have had an additional, more private significance. Just as the former was based on Titian's *Venus of Urbino* [22], so the latter was

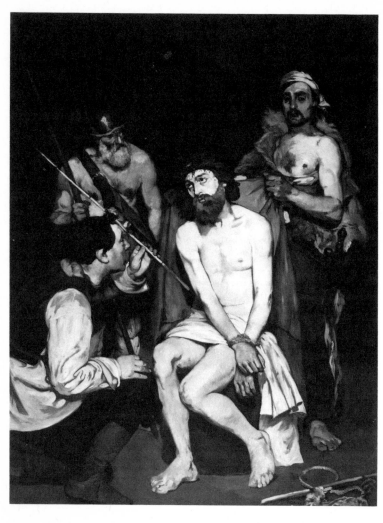

21. *Christ Scourged,*
Manet, 1865

inspired by his *Christ Crowned with Thorns,* which provided the
composition and the central figure's pose, even if, as Thoré ob-
served immediately, the other figures were reminiscent of a well-
known composition by Van Dyck.[12] Moreover, Titian himself was
supposed to have paired pictures of the same subjects in order to
impress an important patron. In the chapter on him in Blanc's
popular *Histoire des peintres,* it was reported that, on being sum-
moned by the Emperor Charles V, Titian brought 'a *Christ Crowned*

with Thorns and a *Venus*, as if to flatter in him feelings of devotion and sensuality at the same time'.[13] This charming story, based on Northcote's biography and ultimately on Ridolfi's treatise,[14] we

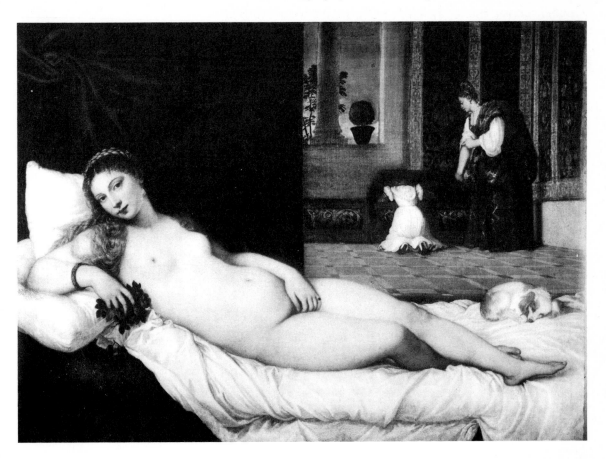

22. *Venus of Urbino*, Titian, *c.* 1538

now know is inaccurate, but it was accepted as true in the nineteenth century and may thus have inspired Manet to identify himself with the Renaissance master not only in the subjects of his two pictures, but in the very act of submitting them together to that sovereign patron in his own society, the Salon public.

There is no evidence that Manet's allusion, if indeed it was that, was appreciated at the time. But then, neither had his previous quotations from Raphael, Rubens, and Velázquez been understood

in a positive sense; they were either ignored or decried as plagiar-
isms. Only recently have we learned to recognize in the fashionable
couple strolling at the right in *Fishing at St-Ouen* not only himself
and his betrothed but the figures of Rubens and Hélène Fourment
on which they are modeled, and in the dandies at the left in *Music in
the Tuileries* not only himself and another artist but the figures of
Velázquez and Murillo on which they are based.[15] In choosing to
identify himself, even if somewhat playfully, with Rubens, Veláz-
quez, and Titian, artists who mingled with the highest society,
Manet affirmed that love of worldliness and elegance which governed
his own life in the salons and cafés of Paris and ultimately gave
Olympia its distinctive tone.

 That his contemporaries did not notice how closely Manet had
followed Titian's example in exhibiting his 'Venus' may not have
surprised him at all; that they failed to realize how closely he had
followed the *Venus of Urbino*'s composition must have disappointed
him greatly. For it is evident that he had not borrowed it simply
because he was unable to invent one, as Bazin and others have
argued,[16] but that he had deliberately alluded to it, assuming that
so celebrated a work would be familiar to a Parisian audience. Sur-
prisingly, the connection was not noted, at least in print, until the
1890s, whereas the dependence of the *Déjeuner sur l'herbe* on a far
less obvious source, a marginal group in an engraving after a Raphael
drawing, was pointed out at once, even if only in passing and in a
footnote.[17] It was in 1890 that Geffroy first described Olympia as
'stretched out on a bed, in the foreground, in the manner of the
courtesans in Venetian paintings'; in 1897 that Bénédite first
identified the composition as 'a modern transposition' of the *Venus
of Urbino*, one which makes us aware of 'all that separates the
courtesan of the past from the prostitute of today'.[18] Since then the
relationship between the two pictures has been discussed repeatedly,
most perceptively perhaps by Meier-Graefe in 1912, but its signi-
ficance has remained obscure even to those who consider it an
allusion, not a plagiarism. As Hofmann, the most recent author, puts

it, Is *Olympia* a modern equivalent of Titian's *Venus* or its complete antithesis, the goddess of love in a new guise or an ironic profanation of all she represented?[19] To answer this question, we must understand the meaning for Manet and his contemporaries of Venetian art, especially Titian's, and of pictures of Venus, especially the *Venus of Urbino*.

*

In the first half of the nineteenth century the great works of the Venetian School had become increasingly popular in France as models of a dramatic, colorful art executed in a brilliantly pictorial style. As we have seen, Couture's masterpiece *The Romans of the Decadence* was largely derived from the monumental decorative compositions of Veronese, and this was fully approved by contemporary critics, who were no less enamoured of Venetian art. Moreover, the technique he employed there and throughout his later career was based on the Venetian masters' use of a sketch-like underpainting as a conspicuous aspect of the final effect; and theirs were the works that he chose as models and encouraged his pupils to copy.[20] Later, in codifying his studio instruction, Couture referred repeatedly to 'Titian's procedure, which remained mysterious for a very long time [but] reveals itself today, when we have the key'.[21] To that instruction, to which he was exposed for six years, Manet undoubtedly owed his own admiration for Venetian art, as seen in his trip to Venice in 1853 and his copies in the Uffizi and the Louvre after works by Tintoretto and especially Titian, among them the *Jupiter and Antiope* and the *Venus of Urbino*.[22] Following his teacher's advice, he did not reproduce these works in literal detail but analyzed their pictorial structure and technique by simplifying their forms into clearly contrasted areas of color, applied with a loaded brush in the manner of an oil sketch. In his copy of the *Venus* [23], the figure's head and glance are averted from us, anticipating as it were the alteration of Olympia's glance in the background of the Zola portrait, but in all other respects it seems 'much

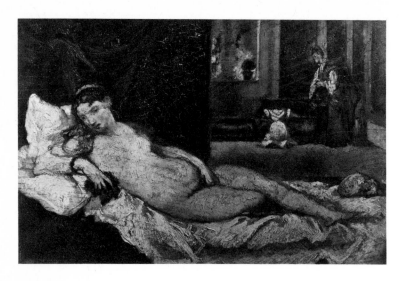

23. Copy after *Venus of Urbino*, Manet, *c.* 1853

closer to us than the original is, containing none of the unreal sweetness of the "divine" figure that Titian represented'.[23] By contrast, the other known copies of the *Venus of Urbino*, which was widely admired and frequently reproduced in this period and the preceding one, are faithful to it in every respect. This is true of Ingres' predictably dry replica, but also of those by Lenbach and Etty, whose biographer called his 'the most Titianesque duplicate ever executed'.[24] Even the copy made by Henner a decade after Manet's merely softens the outlines, giving the whole a slightly blurred, sentimental look.[25]

Titian's *Venus* was not only a famous example of Venetian art, it was also an image of a particular figure, embodied in a particular design. That this design, in which the recumbent nude is disposed in a single foreground plane, thus avoiding the necessity of extensive foreshortening, was a favorite of Manet's is evident in a number of other works, including the *Young Woman in Spanish Costume* and the portrait of Jeanne Duval, as well as *Olympia* itself and the later portrait of Mme Manet, who reclines on a sofa in precisely the same position as the latter but to altogether different effect.[26] That the *Venus of Urbino* is a voluptuously reclining nude, like the central

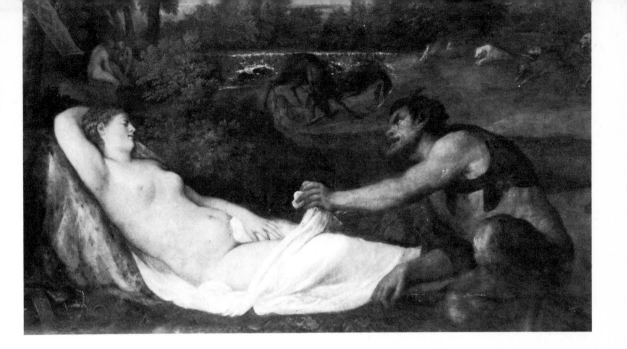

24. *Jupiter and Antiope* (detail),
Titian, 1535-40

figure in *Jupiter and Antiope* [24], which he also copied, was surely
no less important for an artist of Manet's time. Venetian art was
considered more appealing to the senses than that of other schools,
and the recumbent nude, as developed by Bellini, Giorgione, and
Titian, was seen as its epitome. For Alexandre Dumas, 'the mere

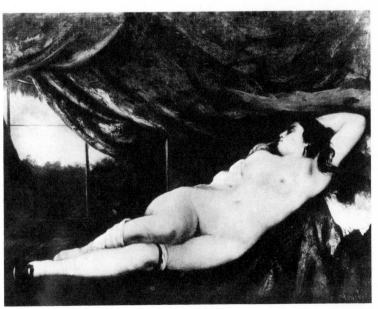

25. *Reclining Nude*,
Courbet, 1862

name of Titian awakens thoughts of delight, pleasure, and love in the coldest hearts', thoughts inspired by 'Venuses with voluptuous forms', etc.[27] For Courbet too such figures were models of sensual abandon. His *Reclining Nude* [25] of 1862, a work contemporary with *Olympia* but at once more carnal and less provocative, was clearly based on the type of sleeping Venus or nymph in Giorgione and Titian, especially on the one in the Louvre's *Jupiter and Antiope*.[28] Similarly, Courbet's *Lady of Munich* of 1869 combined elements of this familiar Venetian type, including the sleeping lap-dog from the *Venus of Urbino*, with the *Rokeby Venus* of Velázquez, itself a variation on that type. And Faustin, in caricaturing the *Lady*

26. Caricature of *The Lady of Munich*, Faustin, 1872.

of Munich [26],[29] substituted a long-tailed black cat for the lap-dog, thus linking it with *Olympia* and at the same time hinting at the latter's link with the Venetian type.

Manet's nude was in fact nicknamed the 'Venus with a Cat', just as Titian's was popularly known as the 'Venus with a Lap-dog'. The goddess of love was by far the most familiar guise in which the

Naissance de Vénus
aux longues jambes.
Drôle de mer que son amere mère.

Autre naissance de Vénus.
Pardon : *La Vague et la Perle* (fable persane.)
Dans tous les cas, ce n'est pas une perle fine, et la vague est bien vague.

Naissance de Vénus
au bras long.
Une des plus jolies choses du Salon.

Naissance de Vénus
écharpée.

27. Caricatures of Salon paintings, J.-J. Baric, 1863

female nude, cleverly and often suggestively posed in the studio, appeared in contemporary Salon paintings. In the Salon of 1863, the year of *Olympia*'s birth, there were three versions of the Birth of Venus, including the widely acclaimed one by Cabanel; and as the cartoonist Baric observed [27], Baudry's entry *The Pearl and the Wave* was in effect 'another Birth of Venus'.[30] How remote these

elegant creatures were from actual women was the theme of a
Daumier lithograph showing two middle-aged ladies fleeing a
gallery hung with paintings of nudes, one of the ladies exclaiming
'This year still more Venuses . . . always Venuses! . . . As if there
were women made like that!'[31] Ironically, the critic Thoré, who
failed to appreciate both the naturalism of *Olympia* and its relation
to the *Venus of Urbino*, condemned the paintings of Baudry and
Cabanel for being unnatural and ultimately less sensual than
Titian's: 'One might find the Venuses of Titian immodest . . . But
our Parisian Venuses don't even possess that attraction of reality.'[32]
And the philosopher Proudhon, author of a treatise on the corrupt-
ing power of women in modern society, described Baudry's 'Venus'
as the very image of prostitution: 'Wicked blue eyes like those of
Eros, provocative face, voluptuous smile; she seemed to say, like the
street-walkers of the boulevards, Do you want to come and see me?'[33]

*

This then was the context in which Manet, in painting a modern
courtesan, could use a famous Venus by Titian as a model and
assume that his allusion would be recognized. But what would he
have thought the *Venus of Urbino* meant? Since there is no evidence
of this other than his copy, which is naturally concerned with the
pictorial qualities of the original, we must turn to the opinions of
his contemporaries. Several interpretations were current, but one
was clearly dominant. If the Goncourts adopted a consciously
aesthetic position, admiring in Titian's nudes 'the magical painting
of a woman's skin, the delicacy of its impossible tones', and Gautier
idealized them, maintaining that the Venetian artist had 'sanctified
nudity by that expression of supreme repose, of beauty fixed
forever',[34] other writers understood them in more realistic, worldly
terms. Typical of this view, familiar in the literature of the time, is
Taine's assertion that the *Venus of Urbino* is 'the mistress of a
patrician, reclining on a bed, adorned and ready . . . She is a courte-
san, but she is a lady; in those days the first occupation did not

exclude the other.'[35] Even Gautier, who was later to deny their sensual appeal, could in his erotic novel *Mademoiselle de Maupin* address 'the brown daughters of Titian, who display so voluptuously to us your undulating hips' as 'beautiful courtesans lying naked in your hair on beds strewn with roses'.[36]

Actually the *Venus of Urbino* shows neither a courtesan nor a lady but the classical goddess of love, here specifically of domestic love, as is evident from such details as the bouquet of roses in one hand, the modest gesture of the other, the lap-dog at her feet, and the marriage chest in the background.[37] But the symbolic language of the Renaissance had become so obscure by the mid-nineteenth century that a French encyclopedia could assert, 'This compostion is mythological only in title', and a German scholar could add, 'This "Venus" is no Venus at all.'[38] Hence Romantic writers such as Dumas were free to imagine the all-too-human circumstances of its creation: Titian, having been commissioned to portray the beautiful Duchess of Este, in fact a former model and mistress of his, persuades her to pose entirely nude and finds to his surprise that she 'has reclined on a sofa exactly in the pose of that divine Venus'.[39] Significant too for *Olympia*, for the tonal contrast between the two figures, is Titian's first glimpse of the Duchess, accompanied by 'a little Ethiopian slave who seemed to have no other purpose than to bring out, by contrast, the whiteness of his mistress'. Thus the *Venus of Urbino*, supposedly an image of the courtesan as a wealthy lady, was for Manet an ideal model for the representation of a similar subject in his own society. Although he could not know this at the time, Stendhal had done precisely the same in describing an elegant prostitute he had seen reclining 'on a bed almost in the costume and exactly in the position of the *Duchess* [i.e. *Venus*] *of Urbino* by Titian'.[40]

In reproducing the design of Titian's picture so closely, even to the placement of the screen behind the nude figure and the silhouette of the maid beside her, which subsumes that of the servants near the marriage chest, Manet was in effect calling attention to the ways

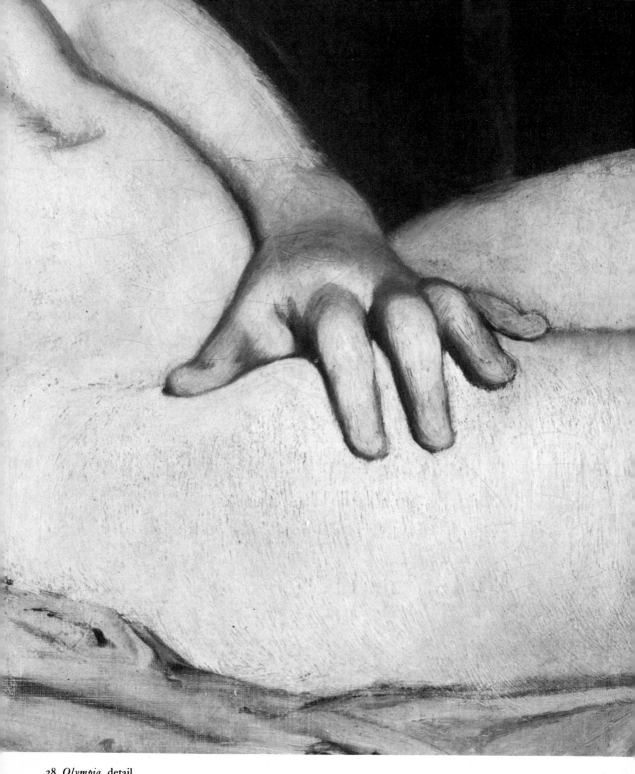

28. *Olympia*, detail

in which his conception differed from the Renaissance artist's. For the palatial room in which Venus reclines, its space extending to the twilit landscape beyond the windows, thus further naturalizing the scene, he substituted a shallow, somber boudoir, closed by curtains at the rear, as if something had to be concealed. Instead of the little lap-dog symbolic of fidelity, he introduced the black alley cat, its back arched defiantly, its green eyes glaring. And in place of the servants arranging clothes, a motif of domestic order and tranquility, he depicted the Negress bringing a magnificent bouquet, one evidently sent by 'a gentleman who had known her [mistress] the night before'[41] or was now waiting behind the dark curtains. Through such alterations, Manet could suggest the extent to which *Olympia* was a modern counterpart to *Venus*, a goddess enthroned to receive a different kind of homage in a society with different values. But it was above all in the nude figure itself that he succeeded in doing this.

In contrast to Titian's ideal of a natural sensuality, conscious of its charm yet somewhat chastened, Manet's is of an elegant artificiality, perversely attractive in its lack of warmth. Unlike Venus, who reclines indolently, entirely at ease with her nudity, Olympia sits more stiffly upright, tense and selfconscious. Unlike the former's completely nude body, unadorned but for a thin bracelet and a pearl earring, the latter's is made all the more naked by the very richness of her accessories – the satin slippers dangling from her feet, the heavy gold bracelet on her arm, the showy red flower in her hair, and the thin black ribbon tied with a pearl around her neck, isolating 'her empty head from her essential being'.[42] Unlike Venus's figure, which is softly, fully rounded, Olympia's is thin, bony, almost emaciated. In this too it reflects a modern taste, one that Baudelaire expresses succinctly: 'There is in thinness an indecency which makes it charming . . . Thinness is more bare, more indecent than fatness.'[43] In the 1860s there was in fact a vogue for slenderness, evidently launched by a few famous courtesans and adopted by fashionable women. Marguerite Bellanger, the Emperor's mistress,

was described as 'below average in size, slight, thin, almost skinny', just as the ladies in his court impressed the Goncourts as having 'an insignificant body, an infinitely small place on themselves for the exercises of love'.[44]

Equally telling are the differences in gesture and glance between *Olympia* and the *Venus of Urbino*. If the latter's hand, lying relaxed over her sex, subtly draws attention to that region, it also conceals it in the manner of the classical Venus Pudica, whereas Olympia's hand [28], its fingers more firmly pressed against her thigh and tensely splayed, conveys at once a greater inhibition and a more deliberate provocativeness. That it was felt as such is clear from Chesneau's remark: 'The odd construction of the "august young woman", her hand in the form of a toad, provokes hilarity . . .'[45] Much was also made of her brazen look, which, in contrast to the warm, inviting look of Titian's nude, as naturally sensual as the indolent tilt of her head, seems in its 'special combination of assurance, indolence, and indifference . . . to hold us eternally upon the point, upon the moment, of recognition'.[46] Though no one remarked this, Manet had evidently adopted one of the most familiar conventions of the erotic prints and photographs of his time, the enticement of a coyly inviting or contemptuously cool glance. In this respect the staring, slightly smiling girls in a lithograph by Achille Deveria [29] and a drawing in *La Vie Parisienne*,[47] though more affected in their gestures and degree of undress, are closer in spirit to *Olympia* than is the *Venus of Urbino*.

Despite its narrative implications, Manet's picture is no more an image of a moment in time than Titian's is. The figures seem frozen in their isolated and unchanging attitudes, the maid offering flowers that her mistress does not receive, the latter staring at a spectator whose position in the room is undefined, even the cat raising its back ambiguously. Instead it is conceived as a juxtaposition of discrete elements, aligned frontally in an almost hieratic manner, each alluding to another aspect of the theme through its connotations. That this apparent meaninglessness was disturbing to a public accus-

29. *She Is Waiting*,
Achille Deveria, 1829

tomed to anecdotal pictures is evident from the questions asked by contemporary critics: 'Is Olympia waiting for her bath or for the laundress?' 'What's to be said for the Negress who brings a bunch of flowers wrapped in a paper, or for the black cat which leaves its dirty footprints on the bed?'[48] In this sense Manet preserved the formal, timeless, unepisodic character of Titian's composition, though inevitably it too was interpreted at the time as a narrative or genre scene.[49]

<div align="center">✳</div>

Paradoxically, Manet's deliberate allusions to older art, in the *Déjeuner sur l'herbe* and other works of the early 1860s as well as in *Olympia*, is one of the reasons that his art of that period seems modern, seems in fact to mark the real beginning of modern art. Allusion, parody, and quotation had of course been widely employed earlier too, in the later Renaissance, for example, and in the late eighteenth century, when a learned artist like Reynolds could

borrow 'attitudes' from Michelangelo, Holbein, and lesser masters in portraying his contemporaries, assuming that they and their circle would appreciate the reference or comparison.[50] But as Harold Rosenberg points out, such devices are far more characteristic of the twentieth century; they 'cut across all contemporary schools . . . [and] introduce into the diversity of this century's modes the unity of the style called "modern".'[51] Characteristically modern too, and in contrast to the eighteenth century, was the incomprehension and hostility that resulted from Manet's use of them; as we have seen, they were either ignored or challenged as plagiarisms. In the case of *Olympia* they were ignored, though the public that viewed it at the Salon was one that had recently applauded Offenbach's operetta *La Belle Hélène* and had previously admired his *Orphée aux Enfers*, parodies of classical mythology in which Venus appears in a surprising new guise.[52] Instead of the knowing approval that it might have elicited in an age so fond of mythological allusions and classical subjects, Manet's gesture seemed ambiguous and disturbing, as if *Olympia* were a strange masquerade.

In an uncanny way it thus fulfilled a prophecy in Baudelaire's essay 'The Painter of Modern Life': 'If a painstaking, scrupulous, but feebly imaginative artist has to paint a courtesan of today and takes his "inspiration" . . . from a courtesan by Titian or Raphael, it is only too likely that he will produce a work which is false, ambiguous, and obscure.'[53] But was it also intended as a reply to this challenge? Manet was not that 'feebly imaginative artist', but his courtesan in the guise of one by Titian did seem 'ambiguous and obscure'. The passage, taken from the chapter on modernity in Baudelaire's essay, has been quoted several times in connection with Manet and even with *Olympia*, but never in this sense. Yet shortly before it was painted the two men were especially close, in fact 'constant companions', and the writer, who was actively attempting to publish the essay, completed early in 1860, undoubtedly discussed its ideas with the most important painter of modern life he knew.[54] Moreover, his choice of Titian and Raphael, although

natural enough in view of their current reputations – the essay begins by evoking 'a Titian or a Raphael, one of those that prints have most popularized' – corresponds to Manet's choice of nude figures by the same two masters as models for what were taken as courtesans in *Olympia* and its conceptual pendant, the *Déjeuner sur*

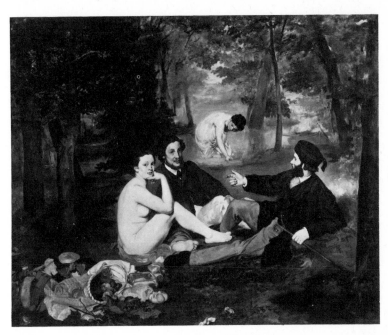

30. *Le Déjeuner sur l'herbe,*
Manet, 1862–3

l'herbe [30]. For just as the former is based on Titian's *Venus*, so the latter is derived from the group of river gods and a nymph in Raphael's *Judgement of Paris*, and just as the *Venus* was thought to represent a courtesan, so nymphs were considered lascivious creatures and in popular speech designated prostitutes.[55]

*

In 1889, before its relation to the Venetian Venus type began to be discussed, Huysmans described *Olympia* as a 'Goya transposed by Baudelaire' and its coloring as a 'Goyaesque rose'.[56] He probably had in mind the *Naked Maja* [31], one of the most striking paintings of the nude in European art and one that is closer than Titian's in

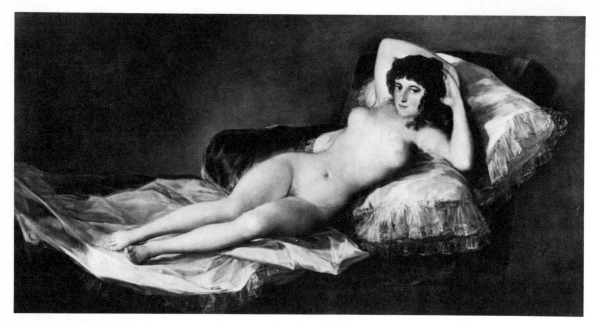

31. *The Naked Maja*, Goya, *c.* 1800

spirit, if not in form, to Manet's. It was mentioned explicitly by
Meier-Graefe in 1902, and again by Mauclair a decade later, but
was first proposed as a source by Jamot in 1927, though in doing so
he virtually ignored the *Venus of Urbino*, as Bodkin pointed out.[57]
Since then both works have appeared regularly in discussions of
Manet's sources, yet the evidence of his familiarity with the *Naked
Maja* is less secure. Like its pendant, the *Clothed Maja* [32], it was

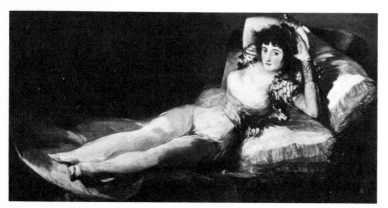

32. *The Clothed Maja*, Goya, *c.* 1800

in his time more often spoken of than actually seen, more a subject of rumors that it depicted the Duchess of Alba, Goya's intimate friend and patron, than an object of personal knowledge.[58] Kept under lock and key at the Madrid Academy, it was rarely shown to visitors and was known neither through photographs nor through prints. Even Gautier, who was certainly an interested enough visitor, mentioned only the clothed version in his *Voyage en Espagne*, though Baudelaire claimed he had seen the other one too.[59] However, a small copy of the latter, falsely identified as autograph, figured in several auctions in mid-nineteenth-century Paris, and Baudelaire himself was familiar with some such copy, as well as one of the *Clothed Maja*. In 1859 he urged the photographer Nadar to buy the two replicas or at least to take photographs of them, observing that 'the very triviality of the pose augments their charm'.[60] Thus it is possible that Manet, already a friend of the poet by then, was also alerted to this interesting find, though he does not seem to have copied either picture, as he did the *Venus of Urbino*. Nor is there reason to assume, as some authors have, that it was one such copy, painted by him, that Baudelaire later owned; the latter's correspondence proves that it was sent to him by an anonymous artist and did not depict either *Maja*.[61]

Manet's own correspondence says nothing about his awareness of Goya's picture before he painted *Olympia*, and instead reveals an ambivalent attitude toward the older artist after he had seen his major works in Madrid in 1865. On the one hand, he accused Goya of a servile imitation of Velázquez and admitted, 'What I have seen of him until now has not pleased me enormously.'[62] On the other hand, he ranked him immediately after his great predecessor and singled out the *Clothed Maja*, the only one on view, as a 'masterpiece' and a 'striking fantasy'.[63] The evidence of his art is also inconclusive, though it does tend to contradict Baudelaire's assertion in 1864 that Manet 'has never seen a Goya . . . People have told him so much about his imitations of Goya that now he is trying to see some Goyas.'[64] As many scholars have observed, his *Young*

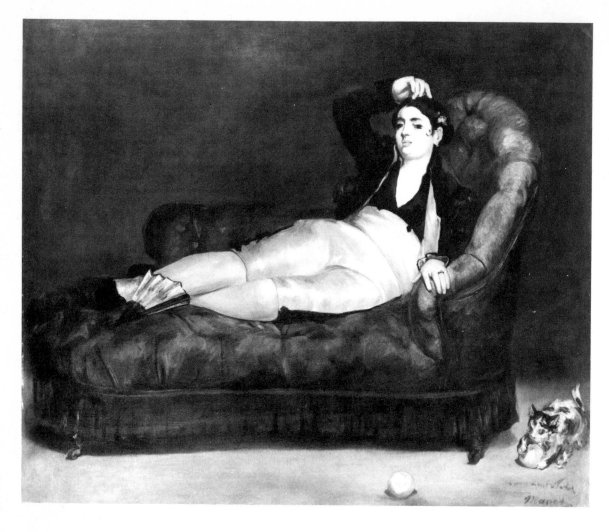

Woman Reclining in Spanish Costume [33] resembles the Clothed
Maja in its pose and choice of national costume as much as Olympia,
its counterpart as an image of the elegant and coolly staring figure
accompanied by a cat, resembles the Naked Maja. And as Joel
Isaacson adds, the latter's influence too is felt in the Young Woman,
in the form of the divan on which she lies: 'Thus, for those who
were familiar with both Goya paintings, a seemingly deliberate
visual pun was created.'[65] Among these initiates was very likely

33. Young Woman
Reclining in Spanish Costume,
Manet, c. 1862

Nadar, whom Baudelaire had asked to photograph copies of the *Majas*; the *Young Woman* is in fact dedicated to him and supposedly portrays his mistress. And she in turn wears a bullfighter's costume, a kind of 'chic flouting of the female image' which was favored by certain courtesans at the time and thereby links the picture with *Olympia* once again.[66]

Whether a direct source for *Olympia* or not, the *Naked Maja* is an important precedent, perhaps the only one in the long tradition of the recumbent nude that is so strongly akin spiritually in its direct, almost brutal vision and selfconsciously erotic attitude. It also marks a crucial stage in the gradual desacralization of the nude within that tradition, replacing the earlier, idealized type of Venus with one that suggests few ideals, either mythological or moral. Yet it looks back to that type as much as it looks forward to *Olympia*, for it was probably based on Velázquez' *Rokeby Venus*, then in the collections of the Duchess of Alba and of Godoy, both of whom were Goya's patrons and played a part in the creation of the *Majas*. But since Velázquez' picture was in turn based on those of Titian, particularly his reclining Venuses, the circle that began with Manet is closed.[67] Despite the *Naked Maja*'s historical ties and spiritual affinities with *Olympia*, it represents a different conception of female sexuality. In Hofmann's words, 'a taut animal intensity lurks in [the *Maja*'s] limbs, which seem in places almost stiff . . . *Olympia* has not this ruthless consistency of physical display, uninterrupted by any accompanying figure. The Maja is a beautiful, dangerous little woman, Olympia a cheaply adorned Paris prostitute borrowing an exotic perfume from the Negress.'[68]

Goya's painting is the most impressive but not the only image of an enticing woman in his work. Several of the plates in his *Caprichos* show fashionable young Majas, probably also inspired by the Duchess of Alba, who are no less provocative though fully clothed; and like *Olympia* they are attended by servants whose contrasting appearance, of age rather than race, provides a foil for them.[69] In one plate [34] the beautiful Maja, flirtatiously exposing

34. *Blush For Her* (*Caprichos*, Pl. 31),
Goya, 1799

35 (*right*). *Reclining Woman*,
Manet, 1862–3

a leg and staring with the same insolent assurance as Olympia, is
flanked by two old women, with one of whom she forms a unified
area of light against the dark background, as in Manet's composition.
Even closer to these Majas, especially to one he later imitated in an
etching, is the reclining woman in a wash drawing [35] that was
evidently one of his earliest conceptions of *Olympia*:[70] both its
treatment of light and dark in flat, strongly opposed areas and its

depiction of the courtesan's elegantly *décolleté* costume are similar. That Manet was familiar with the *Caprichos*, which were widely admired at the time, by Baudelaire among others, is clear from his use of them in several works of the 1860s, including two versions of an emblematic design directly inspired by *Les Fleurs du Mal* and

two etchings of women in Spanish costume that are similar thematically to *Olympia*.[71]

*

The wash drawing of a reclining woman is but one of several studies, either made in preparation for *Olympia* or closely related to it, that shed light on its sources or precedents in nineteenth-century art.

Inevitably, given the popularity of the subject, these studies bring under consideration many artists other than Goya; in fact each of them points to a different type of recumbent female figure and a different way of depicting it. And though their sequence is neither perfectly clear not strictly logical, they also illuminate the development of Manet's conception of the picture and the alternatives he experimented with before adopting Titian's *Venus* as a model.

The wash drawing itself seems inspired not only by the *Caprichos* but by the many studies of prostitutes made by Constantin Guys in the 1850s, studies that Geffroy later compared to Goya's in the 'dreadful truthfulness' of their vision.[72] Uncompromising in their stress on the coarseness and dull complacency of the women he observed reclining on brothel sofas in postures of total abandon [e.g., 36], his drawings are among the few direct precedents for

36. *Reclining Prostitute,*
Constantin Guys, 1850–60

Manet's in subject-matter. Stylistically too they resemble his in their use of large, coloristic areas of wash, although this is not evident in the woodcut reproduction illustrated here. According to his widow, Manet knew and admired the older artist, at least in his later years, when he drew a sympathetic portrait of him and owned some sixty of his works.[73] That he was already familiar with them much earlier seems very likely in view of Baudelaire's great interest in and friendship with Guys, on whose art he based 'The Painter of Modern Life'. Indeed Baudelaire's characterization of his drawings of prostitutes not only applies equally well to *Olympia*, but can be seen as another of those challenges to which it was a response: 'Sometimes, quite by chance, they achieve poses of a daring and nobility to enchant the most sensitive of sculptors, if the sculptors of today were sufficiently bold and imaginative to seize on nobility wherever it was to be found, even in the mire . . .'[74] But if in first conceiving his subject Manet turned to the brothel scenes of Guys, as the Goncourts did a few years later in planning *La Fille Elisa*, a novel of prostitution,[75] he soon abandoned this banal realism for the more colorful, suggestive image of the recumbent woman in Romantic art.

The change in conception is seen in another wash drawing [37], showing the most familiar form of that image, the odalisque or Turkish harem slave.[76] Even the greater colorism of this drawing, its warm sepia tones and white accents, is Romantic in spirit. And the odalisque herself, lying indolently on a pillow, her head resting on her hand, her features evoking a sensual dream rather than bold provocation, has an erotic appeal far closer to that of Delacroix's oriental women than that of Guys' prostitutes. She has reminded one writer of *Sardanapalus* in the swastika-like pattern of her limbs, but is also reminiscent of the most prominent of the *Women of Algiers*, a more relevant subject, and above all of the *Odalisque* shown at the Salon of 1847.[77] Manet may have seen a lithograph of the latter in the magazine *L'Artiste* that reverses it [38], making it more nearly resemble his own figure. He had met Delacroix, whom he

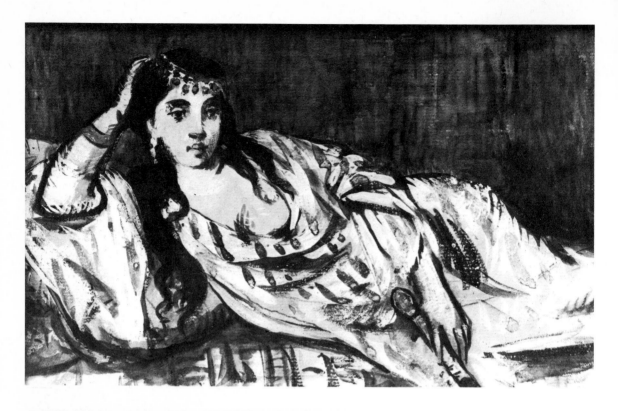

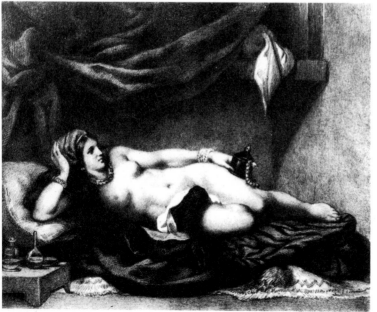

37. *Odalisque*, Manet, 1862–3

38. *Odalisque*, Delacroix, 1847

39. *Nude Woman with Black Cat,*
Manet, 1862–3

40. *Nude Woman with Black Cat,*
Manet, 1862–3

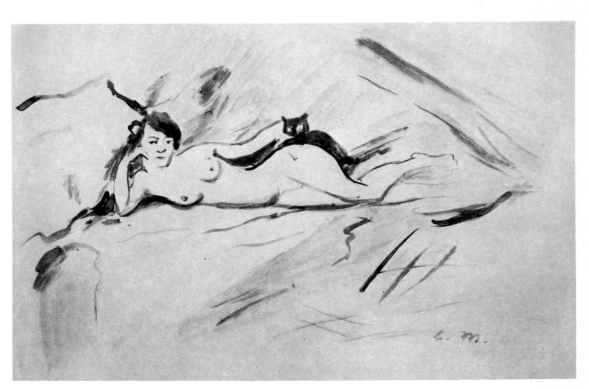

greatly admired, as a young man and had twice copied his *Dante and Virgil in Hell*.[78] Moreover, the *Odalisque* had been highly acclaimed in its time, among others by Gautier, who called it 'a tour de force of colorism', and its reputation may well have survived in artistic circles. Only the greater nudity of Delacroix's figure distinguishes it significantly from Manet's, but this feature appears in all the remaining studies, beginning with the first that is explicitly related to *Olympia*.

This drawing [39] executed in black ink with sweeping strokes of the brush, likewise seems inspired by the Delacroix *Odalisque*, whose fully horizontal figure and heavily draped setting it repeats even more closely.[79] Now however the nude no longer evokes an oriental sensuality; stretched out in her slender, unadorned nakedness on a plain bed and staring directly at the spectator, she embodies a distinctly modern Parisian form of eroticism. The large black cat she caresses with her left hand – in contrast to Delacroix's nude, who holds a jewel box – reinforces this meaning. In a second, more refined drawing [40], in sepia wash heightened with color, she assumes the same pose but holds her head more stiffly upright and looks out more brazenly, in both respects anticipating her appearance in the painting.[80]

The sensual yet idealized odalisques in Delacroix's *oeuvre* were not the only type of recumbent woman in Romantic art nor the most relevant to Manet's psychologically. There also existed, in the work of popular illustrators and printmakers, a more vernacular, sexually suggestive type, of which Noel's lithograph, teasingly entitled *Faithful* [41], is an appropriate example.[81] Here the voluptuous figure assumes virtually the same pose and engages the spectator's glance in the same manner, and the pet she caresses, a black dog who likewise stares at him, makes the same point about her own animality. This close identification of the two creatures received its ultimate expression in another print [42], in which the woman reclining on a sofa, in a very similar posture, is literally transformed into a cat. Designed by Grandville to illustrate one of the stories in

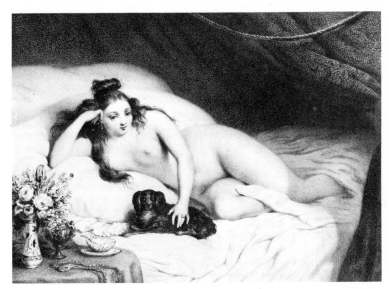

41. *Faithful*, Léon Noel, 1831

42. *I Was Lazy*,
J.-J. Grandville, 1842

a popular collection in which animals dress and behave like humans,[82] it is related to *Olympia* thematically as well as visually. For in the guise of a fairy tale about a pretty cat, the story tells of a young girl who allows herself to be seduced by promises of luxury and is then abandoned, like many of those who in reality became prostitutes in that way.

Reacting perhaps against these Romantic conceptions of the nude, Manet seems to have searched for a more formally coherent and aloof one even before he turned to Titian's *Venus*. This is evident

43. Study for *Olympia*, Manet, 1862–3

in two further studies [e.g., 43], drawn in the more incisive, traditional medium of red chalk.[83] Although some scholars have dismissed them as early academic exercises, unrelated to *Olympia*, they reveal a confidence in the handling of line and tone that belies such a dating. And both in their image of the reclining figure, its limbs arranged in a single plane, its head turned frontally, and their mode of representing it they resemble that picture more than any

44. Study for *Large Odalisque*,
Ingres, 1813–14

45. *Large Odalisque*, Ingres, 1814

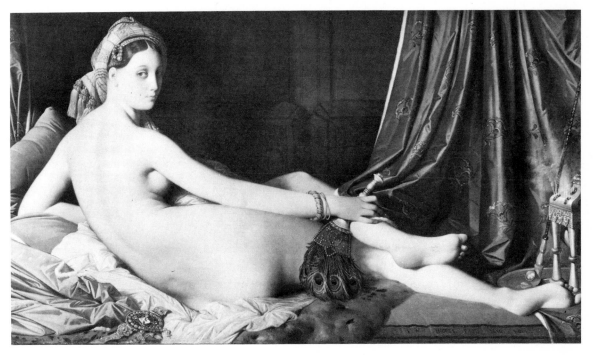

other in his *oeuvre*. What is most characteristic of *Olympia* stylistic-
ally, the concentration or elimination of modeling, the reliance on
line to indicate form and simultaneously to define a continuous
contour, is precisely what characterizes the style of these drawings.
But these features are also typical of Ingres' studies of the nude,
especially the ones he made in preparation for the *Large Odalisque*
[e.g., 44], even if their forms are not flattened as drastically. The

resemblance, at least as far as his paintings are concerned, was already noted in 1897 by Bénédite and a few years later by Proust, who reported Manet's opinion that 'M. Ingres had been the master of masters' and added that *Olympia* 'proceeds . . . from the constant concern M. Ingres had had and Manet wanted to have, to find in the contours of his figures an irreproachable purity of line'.[84] The *Large Odalisque* [45], which was reproduced in several prints, including one of notable 'purity of line' by the master himself, was undoubtedly familiar to Manet; in fact it had already served as a model for the reclining nude at the left side of his teacher Couture's *Romans of the Decadence*.[85] In it he would have discovered not only the clear contours but the concentrated modeling and broad, unbroken planes of light that are equally significant for *Olympia*.

Conceivably Manet could have found the same features in an *Odalisque* by Jean Jalabert, an academic follower of Ingres, that is sometimes cited as a source for *Olympia* because it too shows a Negro servant at one side, her dark skin providing a foil for the nude.[86] But it is unlikely that he would have known the picture, exhibited only at the Salon of 1842, or that he would have seen in it anything but a weak imitation of Ingres. Far more meaningful, despite the obvious differences in composition and scale, would have been *The Romans of the Decadence*, a work he may already have drawn on for the composition of his *Music in the Tuileries*.[87] An image of sensual indulgence and moral decline, which to many contemporaries seemed 'a lesson on the debauchery of luxury and vice',[88] it is not only relevant thematically but depicts, in the very center of the design, a courtesan lying on a couch with the upper part of her body raised and her head turned to gaze directly at the spectator [5]. It was in this figure, already famous in its time, that critics had seen summed up 'all the symbolism of the composition'.[89] But if Olympia resembles Couture's libertine in content and attitude, she has nothing of her archeologically correct costume and dissolute expression, and despite her dependence on Titian's *Venus* is unmistakably a Parisienne of the Second Empire, not a Roman

of the Decadence. It was rather his teacher's interest in themes of corruption and venality, as seen also in his earlier picture *The Love of Gold* and his later one *The Modern Courtesan*[90] [46], that may

46. *The Modern Courtesan*, Thomas Couture, 1873

have been the most significant for Manet, providing the learned allegorical challenge to which his own picture was a realistic response.

If the studies discussed thus far reveal a number of tentative solutions, based on an equal number of nineteenth-century precedents, none corresponds closely to the painting, whereas the final study [47], executed in watercolor over a swift pencil sketch, is virtually identical.[91] Either it was preceded by intermediate drawings, now lost, or, what is more likely, its definitive form reflects Manet's sudden decision to base his composition on the *Venus of Urbino*, using his earlier copy as a guide and posing his favorite model, a young Parisienne named Victorine Meurend, accordingly. For this study differs from the painting only in the greater freshness and luminosity of the color washes, which are applied with a delicate precision. In Olympia's hair, in the screen behind her, and in the curtains at the sides appear deep tones of orange, tan, or green; in the bed and its sheets, paler shades of the same; in the bouquet,

vivid touches of red, blue, yellow, and green. Most of these are more
somber or muted in the painting, at least in its present condition:
that it was originally brighter is suggested by Privat's reference to
the 'light and airy color' of the curtains and by Huysmans' com-
ments on the 'green curtains' and 'blueish linens'.[92] Even then
however the background must have been a darker, more unified
area than in the watercolor, thus providing a more effective contrast
for the light and equally unified area of the figure and the bed.

The bright, delicate tones of the watercolor, together with the
extreme flatness of its planes and the incisiveness of its outlines,
points to an artistic source not considered thus far, the Japanese
woodcut. Like the watercolor study for the *Déjeuner sur l'herbe*,[93]
which it resembles in these respects, it is one of the most convincing
examples of such an influence in Manet's early work, more so than

47. *Olympia*, Manet, 1862–3

the painting itself. Although it is known that he, like Baudelaire and others in his circle, admired and collected Japanese art at this time, scholars have disagreed about its impact on *Olympia*. Some have seen in its clear, abruptly changing colors, its flat backgrounds and flattened, largely shadowless forms, and above all its sharply drawn contour lines, sources of 'that crystal clarity, that somewhat cold transparency which is the ultimate hallmark of *Olympia*' and the surest indication of its derivation from Japanese prints.[94] Others have denied or minimized the latter's role, arguing that the forms are not truly flat but defined by shadows at their edges and heavily impasted paint in their centers, that the contours are not truly decorative but produced by contrasts of tone and a play of shadow and reflection, and that these features can all be found in European art, indeed in the very works by Couture and Ingres that were discussed previously.[95] Ingres' *Large Odalisque* is in fact more closely related stylistically to *Olympia* than any courtesan by Utamaro in its simplified modeling, harmonious contours, and narrow, shadowy setting. Only the sharply detached silhouette of the maid, the bright, abruptly juxtaposed colors of the bouquet, and the delicate floral pattern of the stole reveal the influence of Japanese woodcuts; and appropriately, these features are also seen in the copy of such a woodcut that appears, beside a photograph of *Olympia*, in the background of Manet's portrait of Zola [7].[96]

About the influence of photography, the latest source to be proposed, there is also little agreement; and given the gaps in our present knowledge of its history, this is hardly surprising. That Manet was fascinated by the medium, already very popular by 1860, that he used it as visual documentation in painting portraits and such unfamiliar subjects as *The Execution of Maximilian*, is now well known. But whether the simplified tonal structure of *Olympia*, its light and dark intervals sharply contrasted, its intermediate ones largely suppressed, imitates similar effects in contemporary photographs taken in strong sunlight or brilliant artificial light is less certain.[97] Such effects, coupled with an equally bold attitude to-

ward subject-matter, also occur in the dramatically illuminated paintings of Caravaggio and his followers and, among the sources already discussed, in the etchings of Goya and the oil sketches of Couture. If Manet did draw on recent photographs, it was probably as a source of imagery rather than of style. In the unprecedented realism of the daguerreotype pictures of nudes, whether overtly pornographic or thinly disguised as works of art, that were produced in large numbers during the Second Empire, he would have found a vernacular, erotically charged vision of the naked figure that corresponded closely to his own.[98] Their popularity is attested by many notices, among them one by Baudelaire describing the 'thousand hungry eyes bending over the peepholes of the stereoscope',[99] and by the proliferation of albums containing prints of them. The odalisques and academies of Durieu [e.g., 48], some of

48. *Odalisque*,
Eugène Durieu, 1854

them taken under Delacroix's direction, are remarkably similar to *Olympia* in the directness of their psychological impact.[100] Those of his colleague Braquehais, more popular at the time, are often even more explicit in their use of gesture and glance, of exposure and concealment, for erotic effect.[101] Yet all these photographs reflect

an older image of sexual appeal, closer to that of Courbet, who based one of his nudes on them, and that of Ingres, whose *Large Odalisque* inspired one of them, in the voluptuousness of their models, just as they project an older aesthetic ideal in their modulated lighting and picturesque accessories. In these respects *Olympia* seems, for all its dependence on previous art, more racy and modern in its realism.

Its pictorial structure is in the final analysis an achievement of striking originality, and one perfectly adapted to its content. It conveys both the boldness and the elegance of the starkly naked yet fashionable courtesan, both the drama and the decadence – the former through its flattened forms and strongly contrasted tones, the latter through its svelte contours and precisely drawn details. As Zola astutely observed, in *Olympia* and other early works 'that elegant austerity, that violence of transitions' constitutes 'the personal accent, the particular savor', while 'certain exquisite lines, certain slender and lovely attitudes' betray Manet's 'fondness for high society'.[102] But above all, the novel pictorial effect of *Olympia* lies in its tonal structure, which comprehends forceful oppositions as well as subtle variations. In contrast to a picture like the *Venus of Urbino*, whose light and shade, evenly distributed on the tonal scale, are tempering devices that convey a sense of harmony and serenity, *Olympia*'s tones are concentrated at the extremes of the scale, with relatively few in the intermediate range, giving it the harshness and startling immediacy of a flash-lit photograph. Thus its structure is a formal equivalent of the tense posture and brazen expression of the courtesan herself and a hidden source of her disturbing impact on us. But it also has the opposite effect, forcing us to discriminate the closely related shades of dark and light at either end of the scale, to distinguish the black cat and deep brown Negress from the dark green curtain before which they stand, the ivory-toned nude from the pale yellow stole and white sheets on which she lies, and to sense in them an exquisite, almost decadent refinement that is equally expressive.[103]

In conception *Olympia* is no less original than in execution, despite the number of precedents discussed earlier. What they show, in fact, is that the subject it depicts in a major art form had been treated previously only in minor forms (Guys' drawings and Deveria's lithograph) or in one that was not yet considered art (popular photography), and that its nearest equivalents in a major form had been envisaged in an exotic setting (Delacroix's and Ingres' *Odalisques*) or in an historical or allegorical one (Couture's *Romans* and *Love of Gold*). Manet's achievement lay in combining the vernacular realism of one tradition with the formal power of the other. In doing so he relied on two famous pictures of the recumbent nude that were currently thought to represent immoral women (Titian's *Venus* and Goya's *Maja*), deriving from them the monumental scale and coherence but also the aloofness and fascinating ambiguity of his image. That this was indeed a unique synthesis is shown by the dominance of one or the other tradition in his later treatments of similar subjects.

*

The earliest, an etching [49] probably made in 1868 to illustrate one of the poems in the volume *Sonnets et eaux-fortes*, edited by Manet's friend Burty,[104] is directly related to *Olympia*, since it repeats almost exactly the sepia drawing of an odalisque discussed earlier as a study or precedent for it. Moreover, the sonnet in question, Armand Renaud's 'Fleur exotique', like Astruc's poem on *Olympia* and indeed the picture itself, was clearly inspired by some of the exotic love poems in *Les Fleurs du Mal*, a connection Burty evidently recognized when he invited Manet to illustrate it.[105] That the etching was based on a drawing made five or six years earlier is surprising, but even if there is no certainty that it dates from 1868, it can hardly be dated 1862–3 either stylistically or technically. It is more likely that the drawing was made later, and in fact its image of the odalisque corresponds rather closely to that of the recumbent harem slave in the sonnet; yet most scholars accept the earlier date and see

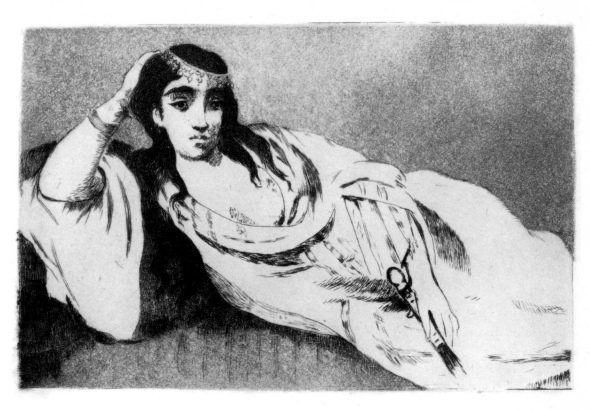

49. *Odalisque*, Manet, 1868

in its model a resemblance to the one who appears in other studies related to *Olympia*.[106] In any event, the etching clearly reverts to the type of languid, exotic sensuality found in those studies, abandoning both the challenging modernity and the erotic tension of the picture itself.

In *The Lady with the Fans* [50], a portrait of Nina de Callias painted in 1873,[107] Manet returned to that type again, repeating in the figure's indolent pose and the small animal near her motifs he had explored a decade earlier, notably in the wash drawings of a woman with a cat. Now however the young woman whose gaze engages our own is a stylishly dressed Parisienne of the artist's acquaintance rather than a nude model reminiscent of traditional art, and her pet is a playful white pekinese rather than a black alley

cat. The pekinese, like the Japanese wall hanging and the fans scattered over it, is part of an elaborately oriental setting that reflects both the artist's greater interest at this time in colorful effects and the sitter's picturesque bohemian milieu.[108] Her toilette, with its jet black skirt, embroidered bolero, and gold bracelets set against

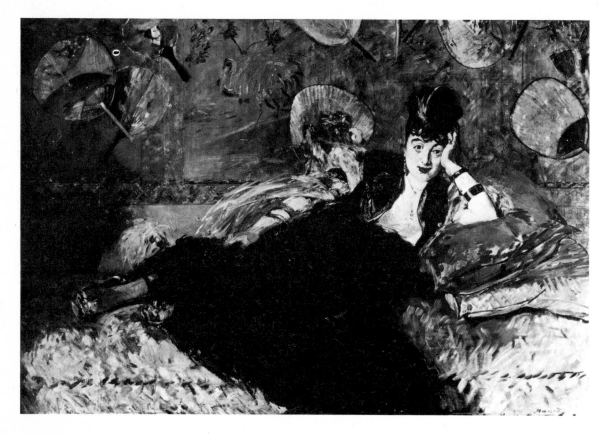

50. *The Lady with the Fans,*
Manet, 1873

her white flesh, confirms this unconventionality and suggests a somewhat gaudy sensuality; as Blanche observed, the white and black of the Baudelairean figure is as salacious as 'La Malabaraise' in the *Fleurs du Mal*.[109] Nina de Callias was in fact such a person: estranged from her husband, the critic Hector de Callias, she led a riotous bohemian existence, surrounded by artists, writers, musi-

cians, and radical politicians, one of whom later described her as 'a small, plump, vivacious, slightly hysterical young woman, who had a well-deserved reputation for eccentricity, excess, and frank hospitality'.[110]

As a marginal allusion to this aspect of her personality and behavior, Manet may have introduced the crane in the center of the wall hanging. Sometimes called an ibis, it is identifiable by its coloring and markings as a Japanese Crane (*Grus Japonensis*) and was no doubt present in the hanging. Yet he chose deliberately to include it, just as he chose to suppress it in depicting the same textile three years later in his portrait of Mallarmé.[111] Clearly it would have been inappropriate, whereas in *The Lady with the Fans* it signified, as it did in popular speech and imagery, both a 'foolish, empty-headed girl or woman' and a 'more than fast girl, kept woman, or "demi-rep"'.[112] A contemporary caricature alluding to the same features in the Empress Eugénie's character [51] showed her literally metamorphosed into a crane.[113]

The same bird appears in the background of the most famous of *Olympia*'s descendants, the *Nana* [52] of 1877, but rendered in a more prominent manner and more obviously linked to the woman herself, whose stance and coloring it echoes.[114] Here of course it carries its most familiar meaning, that of 'kept women' or 'demi-rep'. It was well known that Manet's model, the actress Henriette Hauser, was a *grande cocotte* kept by the Prince of Orange (and was therefore nicknamed Citron). But his inspiration was also literary: the Nana episode in *L'Assommoir*, which appeared in serial form in the very months when he planned and executed the picture. In a letter of that time he informed Zola he was reading it and found it 'amazing', and in a notice on the painting published a year later Huysmans, announcing Zola's intention to write a full-length novel on the subject, congratulated Manet for having 'shown her as she will undoubtedly be [in it], with her complex, refined vice, her extravagance, and her wealth of lewdness'.[115] The novel, not pub-

51. Caricature of the Empress Eugénie, Paul Hadol, 1871

lished until 1879, may in turn have been indebted to the painting for its vision of Nana preening herself in her elegant boudoir while the Count Muffat looks on, though it is also true that its conception dates from 1868, a time when Zola was preoccupied with Manet's earlier works, and may therefore owe something to the image of the courtesan as a goddess of love in *Olympia* itself.[116] Between the latter and Zola's novels however there could exist only a general affinity of that sort, for it avoids the kind of episodic realism that the later painting shares with them. Like Olympia, Nana stares defiantly at the spectator; and like Olympia's black cat, the crane in the tapestry alludes to her character and profession. But the translation of such symbolism into compact, monumental forms is not realized in this naturalistic 'slice' of modern life. Cleverly composed, with Muffat and other elements cut at the borders to suggest both alienation and instability, it lacks the pictorial power and dramatic concentration of its great predecessor.

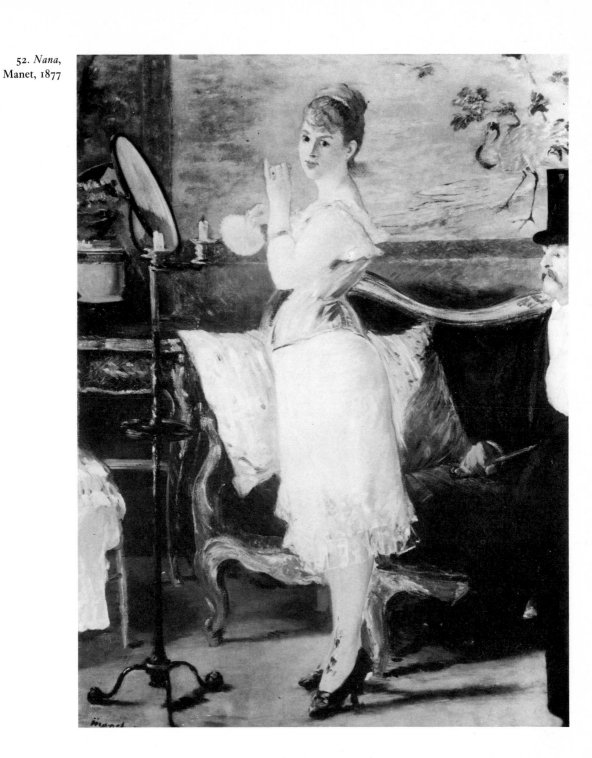

3. Literary Sources and Content

If the literary equivalents of *Nana* are in some of Zola's novels of the 1870s, those of *Olympia* are in certain poems by Baudelaire published twenty years earlier. The change in orientation reflects, as we have seen, a fundamental change in Manet's art during that time, one that Zola himself was quick to emphasize. Acknowledging the rumors that had linked them for several years, he took pains in 1867 to 'denounce the relationship some people have wished to establish between Manet's paintings and Baudelaire's poetry'.[1] By insisting that the artist 'has never been guilty of the stupidity committed by so many others of wishing to put ideas into his paintings', Zola may have sought to deflect criticism from their subject-matter, which was bound to appear 'Baudelairean' in a provocative sense, to their pictorial qualities. But he may also have hoped to identify them with his own aesthetic of analytic observation rather than the Romantic one of imaginative expression. Since then many writers have implicitly rejected his view in commenting on the Baudelairean aspects of *Olympia* and other early works, while some have continued to maintain that such comparisons constitute a 'false and morbid rhetoric' or at best reveal 'only a very general affinity for certain modern subjects'.[2] Yet none has examined *Olympia*, the most interesting case of all, in sufficient detail.

That the two men were closely acquainted and admired each other's work from the late 1850s on, that they shared a taste for certain types of traditional art and a conviction about the forms that modern art should take, is evident from their correspondence,

from the memoirs of those who knew them, and from their works themselves – the painter's sympathetic portraits of the poet and his mistress, the poet's perceptive writings on the painter and his pictures.[3] As Hamilton and others have noted, there are also specific parallels at times; for example, between the color and mood of *The Absinthe Drinker* and those singled out as distinctly modern in the *Salon of 1846*, and between the physiognomy of *The Street Singer* and the one described in 'Les Promesses d'un visage'.[4] There are even instances, less well known, of Manet turning directly to Baudelaire's poetry for inspiration, notably in an unpublished drawing based on the notorious 'Femmes damnées'[5] and in two others summarizing in emblematic form the poet's principal themes and artistic preferences, one of which was probably intended as a frontispiece for his collected verse, the other as a posthumous homage.[6] But the most important example is undoubtedly *Olympia* itself.

Too much has been made, by those who wished to deny this inspiration, of Baudelaire's somewhat vague reference to *Olympia*, in a letter to Manet of 1865, as 'the painting of the nude woman with the Negress and the cat (is it really a cat?)'.[7] For whether or not he saw it in the artist's studio before leaving for Brussels, his poetry played an important part in its conception. If *Olympia* does not illustrate any of *Les Fleurs du Mal* literally, it depicts motifs like the Negress, the cat, and the jewelled, naked flesh that recur in many of them, and it is charged with a spirit of artificiality and malevolence that pervades almost all of them. The courtesan rarely figures as such; it is rather in the love poems evoking the fatal beauty of his mistress that we find close affinities with Manet's picture.[8] Just as Olympia's slender proportions recall that seductive thinness which the poet had described in 'Une Martyre':

> Et cependant, à voir la maigreur élégante
> De l'épaule au contour heurté,
> La hanche un peu pointue et la taille fringante
> Ainsi qu'un reptile irrité,

so her insolent stare recalls the one whose metallic gleam had fascinated him in 'Le Serpent qui danse':

> Tes yeux, où rien ne se révèle
> De doux ni d'amer,
> Sont deux bijoux froids où se mêle
> L'or avec le fer.

The glitter of her jewelry, indeed the very paleness of her coloring, are like those he had envisaged in the sonnet 'Avec ses vêtements ondoyants et nacrés':

> Où tout n'est qu'or, acier, lumière et diamants,
> Resplendit à jamais, comme un astre inutile,
> La froide majesté de la femme stérile.

In the same way her satin slippers, symbols of her taste for luxury and domination, resemble the ones he had described in the 'Chanson d'après-midi':

> Sous tes souliers de satin,
> Sous tes charmants pieds de soie,
> Moi, je mets ma grande joie,
> Mon génie et mon destin.

Even the method Manet used in reshaping a Renaissance nude according to a modern ideal resembles the one Baudelaire used in alluding to Correggio's *Jupiter and Antiope* in 'Les Bijoux':

> Je croyais voir unis par un nouveau dessin
> Les hanches de l'Antiope au buste d'un imberbe.

In fact 'Les Bijoux', more than any other poem in *Les Fleurs du Mal*, bears so striking a resemblance to *Olympia* in its images of a nakedness enhanced by jewelry:

> La très-chère était nue, et, connaissant mon coeur,
> Elle n'avait gardé que ses bijoux sonores,

and of a sensuality at once indifferent and selfconscious:

> Les yeux fixés sur moi, comme un tigre dompté,
> D'un air vague et rêveur elle essayait des poses,

that, as Hamilton notes, in 'reading it now one cannot but wonder how much of the expressive quality of *Olympia* may have been due to Manet's having heard from Baudelaire's own lips, in the early days of their acquaintance, the magical words which parallel the cold, haughty beauty of his painted image'.[9]

In addition to the nude figure, each of the other motifs in the picture – the Negress, the black cat, the bouquet of flowers – has its equivalent in Baudelaire's poetry, as well as in other works of art and literature of the period. And in reinforcing the meaning of the nude, each of these motifs adds another dimension to the meaning of the whole.

<p style="text-align:center">*</p>

Inspired by memories of the Negresses and mulattos he had seen on a youthful voyage to the islands of Réunion and Mauritius, Baudelaire celebrated their dark, gleaming beauty, their natural sensuality, and the lushness of their exotic milieu in 'A une Malabaraise', 'A une dame créole', and other early poems. In 'Bien loin d'ici' he went further, intimating that the indolent, elegantly dressed Dorothy,

> cette fille très-parée,
> Tranquille et toujours préparée,

was a dark-skinned prostitute.[10] And in the related prose poem 'La Belle Dorothée', which is exactly contemporary with *Olympia*, he pictured her as walking to a rendezvous under a tropical sun, 'her dress of clinging silk, of a light rose tone, standing out vividly against the darkness of her skin' precisely the way the maid's does in that work.[11] In addition to his memories of the islands, Baudelaire had a source of inspiration closer to home, the mulatto woman Jeanne Duval, who was his mistress and evil genius for many years and the subject of a cycle of poems devoted to 'la Vénus noire'; she whom he addressed in 'Sed non satiata' as a

Bizarre déité, brune comme les nuits,
Au parfum mélangé de musc et de havane,
Oeuvre de quelque obi, le Faust de la savane,
Sorcière au flanc d'ébène, enfant des noirs minuits.

It is perhaps significant for the visual and social contrast between the two women in *Olympia*, and for its origin in a picture of Venus, that the other major cycle of love poems in *Les Fleurs du Mal* is devoted to 'la Vénus blanche', the famous courtesan Apollonie Sabatier, who was also briefly his mistress but mainly his intimate friend and muse.[12] It was Jeanne Duval to whom he was most fatally drawn, she whom Courbet had already shown at his side, looking coquettishly into a mirror, in *The Artist's Studio* in 1855 and whom Manet had portrayed at his request, reclining on a sofa in a manner like Olympia's, the year before the latter was painted.[13] Here, as in Picasso's youthful parody, the recumbent *femme fatale* and her black servant were combined in a single figure.

In that role the Negress merely made explicit what was already implied in her subordinate role, a sensuality whose exoticism subtly reinforced that of the image as a whole. Since the later eighteenth century, when Europeans came into contact with them in large numbers, black women had generally been considered more uninhibited and passionate than white women and more desirable as lovers. The Abbé Raynal explained this as 'an ardor of temperament which gives them a power to arouse and experience the most burning raptures'.[14] Virey's widely read *Histoire naturelle* offered a different explanation: 'Negresses carry voluptuousness to a degree of lascivity unknown in our climate [because] their sexual organs are much more developed than those of whites.'[15] In Romantic literature the amorous native woman, deceived or abandoned by her white lover, was a familiar figure, although she was gradually transformed into the one who sought revenge for her social inferiority by holding him enslaved to passion, as in Baudelaire's case. That her sexual superiority was still proclaimed toward the end of the century is clear from the comment recorded in Flaubert's *Dictionnaire des idées*

reçues: 'Negresses. More passionate than white women (see Brunettes and Blondes)', though his reference to the latter, each of whom he called more ardent than the other, showed how ridiculous he thought such comparisons were.[16] Thus the Negress in *Olympia* must have connoted for contemporary viewers a primitive or exotic sensuality, enhancing what Valéry later spoke of as the 'primitive barbarity and ritual animality' of the naked, elegantly adorned courtesan herself.[17]

Behind Manet's conception lies not only this literary tradition but a well-established artistic tradition, in which the figures he depicted as mistress and maid, the one white and nude, the other black and clothed, were similarly juxtaposed. In pictures of women bathing with attendants, whether biblical, classical, or modern in inspiration, the two types had appeared together since the eighteenth century. Joseph Vernet's *Greek Woman after the Bath* of 1755 shows a 'black woman paying homage to white beauty in an age of colonialism', and Nattier's *Mlle de Clermont at the Bath* of 1733 shows her attended by the oriental and black maids of 'a third world domestic staff'.[18] By the middle of the following century the subject had become a voluptuously idle odalisque attended by a darker-skinned, music-making servant, as in Ingres' well-known painting of 1839 and Flandrin's replica of 1842, both images of a kind of hothouse exoticism.[19] Jalabert's *Odalisque*, discussed earlier as a possible source for *Olympia*, is another example. Shortly before painting the latter Manet himself had represented a Negress as a white woman's servant in his unfinished *Finding of the Infant Moses* and in the first version of his *Surprised Nymph*, while in his *Children Playing in the Tuileries* he had shown her playing a similar part in a modern setting.[20] In fact he had employed there the same model, identified as 'Laura, a very beautiful Negress', that he would use in an oil sketch made in preparation for *Olympia* [53].[21] Only the fashionable toque, the pearl earrings, and the heavy gold necklace that she wears in the sketch make it clear she is a companion more suitable for a wealthy courtesan than for a group of children.

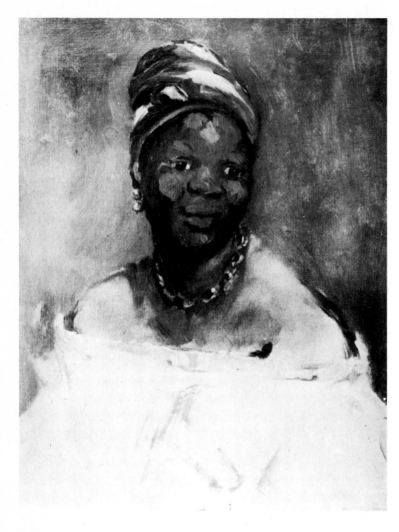

53. *The Negress*,
Manet, 1862–3

For this role too there were precedents in earlier nineteenth century art, particularly in the numerous prints of deliberately equivocal intention which flourished then. In them the varied retinue favored by the previous age was gradually eliminated or reduced to a single servant, and her function increasingly became that of displaying her mistress to the spectator, as if he were a client.[22] Exotic and sensual in her own right, the dark-skinned maid became the courtesan's natural companion, one whose coloring enhanced

the fairness of her own complexion. In this double role she also figured in Sigalon's *Young Courtesan* [54], which had been bought by the Luxembourg Museum after its success at the Salon of 1822 and was still widely admired in Manet's time for its Venetian tonality and handling.[23] As an actor in the intrigue, she urges discretion on the young lover hidden behind her mistress, while the latter grasps the jewel box offered by the older admirer; as a darkly complected figure, she reinforces the dazzling whiteness of her mistress, who is placed directly before her – an effect much admired

54. *The Young Courtesan*, Xavier Sigalon, 1822

in the 1860s. By that time the Negress seems to have been widely identified as a companion of prostitutes or as one herself. Thus the Goncourts, collecting material for *La Fille Elisa* in the very year *Olympia* was painted, reminded themselves to 'make the prostitute's friend a Negress, study the type and incorporate it in the story'.[24] In the novel, published fourteen years later, she is Peau-de-Casimir, no longer a subordinate figure but one of the stars of the brothel herself.

*

Like the Negress in *Olympia*, the black cat seems in retrospect 'too intimately a Baudelairean symbol not to have wakened in the minds of the spectators of 1865 ... memories of those cats who stalk through the pages of the *Fleurs du Mal*'.[25] In fact none of the reviewers mentioned the latter; from Thoré at that time to Claretie and Fervacques years later, they were unanimous in calling Olympia's pet 'the black cat of Hoffmann' and 'assuredly a near relative of Hoffmann's celebrated Murr'.[26] The 'Contemplations of the Cat Murr' was indeed one of the best known of the German writer's brilliant and often fantastic tales, which were extremely popular in France; but its philosophical treatment of the lives of Murr, a writer, and of Kreisler, a musician, each reflecting another aspect of Hoffmann's eccentric personality, has little to do with Manet's picture.[27] Some of Baudelaire's poems seem far more relevant,[28] both to the preparatory studies of a woman caressing a black cat, like the one in 'Le Chat':

> Lorsque mes doigts caressent à loisir
> Ta tête et ton dos élastique,
> Et que ma main s'enivre du plaisir
> De palper ton corps électrique,

and to the final painting, where the cat at her feet is a symbol of sensuality, like the one in 'La Géante':

> J'eusse aimé vivre auprès d'une jeune géante,
> Comme aux pieds d'une reine un chat voluptueux.

Fascinated by the analogy he drew here and in the poem 'Les Chats' between women and cats, creatures in whom an animal magnetism mingled with a moral indifference, Baudelaire was the most likely source for the analogy Manet in his turn drew in *Olympia*. It was of course much older than either of them, already occurring in the seventeenth century in La Fontaine's fable 'La Chatte métamorphosée en femme' and in the early nineteenth century in Hoffmann's 'Contemplations' and the story illustrated by Grandville that was discussed previously.[29] What distinguishes the analogy drawn by

55. *Olympia*, detail

Baudelaire and Manet is its insistence on the feline as a sexual surrogate of the female.

In the scandal surrounding *Olympia*, the black cat at her feet epitomized all that was considered outrageous or perverse in the picture [55]. Its inky silhouette and provocatively raised tail were, as we have seen, conspicuous features of almost every caricature, even those in which the figures were absent,[30] and the nickname 'Venus with a Cat' was soon in common use. No allusion to Titian's picture, popularly known as 'Venus with a Lap-dog', was intended, yet Manet's substitution of one creature for the other summarized his meaning perfectly. If the little white lap-dog symbolized marital fidelity, the black alley cat, depicted in a defiant posture with its back arched and its long tail raised, clearly stood for promiscuity. In exaggerating the size and rigidity of the tail, which Manet seems initially to have shown bent limply downward, the caricaturists all sensed its phallic significance. On the other hand, the words 'cat' and 'pussy' were also used in popular speech, as they are today, to designate what the *Dictionnaire érotique moderne* defined in 1864 as 'the name that women give to the divine wound they have below their bellies'.[31] In popular erotic prints the image had the same double

56. *In the Boudoir*,
artist unknown, 1860

meaning: in an eighteenth-century French engraving, a cocotte lifting her skirt to fasten her garter is accompanied by a black cat who, standing directly below her, stares knowingly at the viewer; in a nineteenth-century German lithograph contemporary with *Olympia* [56], a voluptuous odalisque raises her scarf to tease a cat who leans against her thighs with a doleful expression.[32]

How familiar these connotations were in Manet's circle is evident from Champfleury's book *Les Chats*, a monograph published in

57. *The Cats' Rendezvous,* Manet, 1868

1868 on the occurrence of cats in art, literature and folklore from ancient Egyptian to modern times. In it he cited many legends of their sexual license based on the very aspects of the alley cat's appearance – its bristling black fur and glaring green eyes – that characterize Olympia's pet. It was in fact to illustrate the chapter on the mating ritual of cats outdoors, which Champfleury described as 'more violent than indoors . . . ferocity mingling with the transports of love', that Manet designed his lithograph *The Cats' Rendezvous* [57], showing a black cat, clearly descended from Olympia's, stalking a white one on a roof-top.[33] That it was successful as an illustration is suggested by the publisher's choice of it as a poster to advertise the volume. It is composed with a sense of the expressive power of black and white as powerful as that in the earlier painting; and as Manet himself explained, the contrast between the two creatures is repeated in the background, where 'the chimney pipes correspond to the black cat and the mottled white moon, [seen] through the clouds, forms a kind of complement to the white cat'.[34]

In addition to its sexual significance, the black cat in *Olympia* had a darker, more malevolent meaning. As Hofmann points out, 'the cat is not simply an Imago of the female principle, but one of the symbols used by the nineteenth century instead of the Sphinx', and the poems in *Les Fleurs du Mal* equating the female with the Sphinx, and the cat with both creatures, are but a few instances of such symbolism.[35] More explicitly diabolical is the meaning of the black cat in Poe's tale of that title, which was translated by Baudelaire in 1857 and illustrated by Legros, another friend of Manet's, in 1861. (On a list of pictures and prints he intended to dispose of, Baudelaire noted that he would give Manet the 'Cats by Legros'.)[36] Poe's story begins with an allusion to 'the ancient superstition that all black cats are sorcerers in disguise' and concludes with a dramatic episode that confirms its validity: it is the howling of an ominous black cat, buried alive in a cellar wall with a murderer's victim, that betrays his crime.[37] This deeply rooted belief that black cats were the natural companions of witches and others possessing evil powers was also

discussed at length in Champfleury's book, and may well be another reason for the violent reaction to Olympia and her pet. There may even be a connection between the latter and the black cat shown in Legros' illustration of the dramatic dénouement of Poe's tale [58];

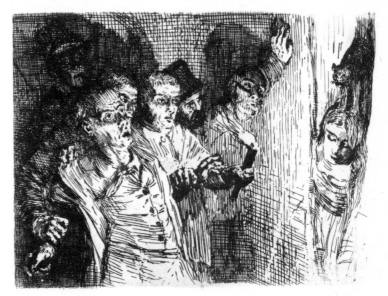

58. Poe's *Black Cat*, Alphonse Legros, 1861

only in their contexts, the one creature standing on a dead woman's head, the other at a live woman's feet, are they really different.[38]

✳

Unlike the cat and the Negress, the bouquet of flowers in *Olympia* seems devoid of any meaning other than the one already discussed, that it was sent by 'a gentleman who had known her the night before'. Rendered as bright spots of color – white and pale blue with accents of red and deep green – it seems primarily pictorial in purpose: to provide a second focus, equal in strength to the nude figure's head, and to introduce an area of varied pattern, in contrast to the broad, unbroken planes found elsewhere. Visually, it is linked with the large flower in Olympia's hair and the floral stole beneath her feet. But like the other motifs, it becomes more meaningful, and more Baudelairean, when seen in its cultural context.

That Manet could evoke the malevolent mood of the *Fleurs du Mal* as well as some of its favorite symbolic forms is evident in his etching *Cat and Flowers* [59].[39] Executed in the summer of 1869, six years after *Olympia*, it recalls the latter in its ominously dark background, its oddly glowing flowers, and its sinister cat, but is even more obviously Baudelairean in its juxtaposition of them. It may in fact have been conceived as a homage to the recently deceased poet, rather like Morin's drawing of him seated at his window, a cat on

59. *Cat and Flowers*, Manet, 1869

his shoulder and a vase of flowers labelled 'Fleurs du Mal' beside him, which was published in Champfleury's book earlier in the year.[40] Certainly the composition of Manet's print is highly contrived, almost emblematic in character, its forms flattened and compressed within a shallow space, its scale altered to make the cat loom dangerously large, while the flowers – evidently drawn from a bouquet, not a plant – seem shrunken on their short stems. In this flatness and arbitrary proportioning, moreover, Manet's composition is like the Japanese ones that he and Baudelaire both admired. Even the decoration of the vase with a tiny stork, wittily shown flying toward the cat, recalls some of those prints,[41] as well as the tapestry in *Nana* and *The Lady with the Fans*.

In contrast to the flowers in the etching, those in Olympia's bouquet glow in a fresher, more natural manner [60]; to call them 'fleurs du mal' is merely to play on words. Nevertheless Manet can hardly have ignored the symbolic significance that Baudelaire attached to flowers, particularly as it manifested itself around 1860 in his efforts to persuade the engraver Bracquemond, who was also a friend of Manet, to produce the kind of emblematic design he envisaged as a frontispiece to the second edition of his volume.[42] What he wanted was an image of the Garden of Eden with the tree of knowledge metamorphosed into a skeleton and surrounded by seven tall flowers symbolizing the deadly sins. What he got seemed far too pedestrian and was rejected, as was the design, mentioned earlier, that Manet too seems to have submitted. It was only in 1866, in the frontispiece to *Les Epaves* drawn by Rops, an artist closer to his heart in matters diabolical, that his scheme was finally realized.[43] His criticism of Bracquemond's version sheds light not only on his own notion of flower symbolism but on that of his contemporaries: 'Those flowers were absurd. For all that it would have been necessary to consult the books on analogies, the symbolic language of flowers . . . Never will he be able to represent the sins in the form of flowers.'[44] For it was at just this time that interest in the language of flowers was at its height.

60. *Olympia*, detail

Derived both from the oriental practice of sending bouquets, or *Selams*, as discreet messages of love and from the Romantic habit of investing natural forms with human significance, this language was in vogue in the period 1830–80, when scores of manuals giving the 'meaning' of each flower and plant and their combinations were printed and reprinted.[45] *Les Fleurs animées*, a two-volume work published in 1845 with engravings by Grandville, in which the blossoms themselves were imagined as whispering the secret of their origin and meaning, was especially popular. A comedy derived from it was produced in Paris one year later with Baudelaire's mistress, Marie Daubrun, playing the part of La Pensée.[46] The more realistic Social Drama of the following decades avoided this kind of fantasy but continued to depict the offering of symbolic bouquets, often in scenes related to *Olympia* in content. In Augu's *Les Femmes sans nom*, a picture of the Parisian demi-monde, an elderly merchant courting a woman of that class brings her a large bouquet, explaining the sentimental significance of each flower, and she promises to return the compliment.[47] In Dumas fils' *La Dame aux camélias*, its famous predecessor, much is made of the camelia as an emblem of the beautiful demi-mondaine, who will wear only that species; when her maid brings a bouquet of other flowers from a suitor, in a scene reminiscent of *Olympia*, she rejects it.[48] After the success of Dumas' play, many others were produced on the same theme, some referring directly to it – *Diane de Lys et de camélias*, *La Bonne aux camélias* – others alluding to a well-known verse by Malherbe to suggest the courtesan's fleeting beauty and renown – *Ce que vivent les roses, Ce que deviennent les roses*.[49] And at least one *grande cocotte* of the period imitated Dumas' heroine: Marguerite Bellanger, the notorious mistress of Napoleon III, was invariably portrayed with marguerites in her hair or at her neck [e.g., 61].[50]

The flowers in Olympia's bouquet have rarely been identified, and then incorrectly: Reifenberg refers to their colors rather than their species in calling them camelia red, forget-me-not blue, and white; Hopp wrongly labels the central one an umbel.[51] It is pos-

sibly a gardenia but more likely a white tea-rose, a species more popular in France. Surrounding it are white and red rose-buds and pale blue blossoms that remain unidentified, largely because they were repainted to enhance the bouquet's color harmony and are now blurred. Around the outside are several deep green sprays of fern.[52] Thus the bouquet consists primarily of roses, the most widely cultivated and admired flower in France, but one which for that very reason had the most varied connotations. From antiquity onward however it had been a symbol of love and beauty, an image of the transience of beauty, and an emblem of Venus, all of which would be appropriate for Olympia; and in the manuals of flower symbolism the moss-rose stood for voluptuous love and the Bengal rose, a type of odorless tea-rose, for sterile or strange beauty, which would be equally appropriate.[53] According to *Les Fleurs animées*, the Romans of the Decadence 'adored only one type of woman, the courtesan, and knew only one flower, the rose',[54] and the same could be said of the Parisians of the Second Empire, a period already compared to the Roman Decadence at the time. In fact it *was* said, in the popularity of the courtesan as a theatrical type and in the frequency with which she was identified with roses. In addition to the plays already cited – *Ce que vivent les roses* depicting her triumph in society, *Ce que deviennent les roses* her eventual decline – *Rose et Rosette* and *Les Diables roses*, which deal with the same phenomena, may also be mentioned.[55] What remains uncertain is whether Manet, who according to Zola introduced the bouquet into his composition solely because he 'needed clear and luminous tones', also intended it to carry a symbolic meaning.

Elsewhere in his work, and in *Olympia* itself, there are indications that he did. If most of his floral still lifes, swiftly executed studies of peonies, roses, and white lilac, arranged in simple bouquets, confirm Zola's interpretation, the *Bunch of Violets* [62] of 1872 evokes a wider range of associations.[56] With the elegant fan and formal invitation shown beside it, the little bouquet constitutes a lady's memento of a ball, one made more meaningful by the names inscribed on the invi-

61. Title-page of Marguerite Bellanger's *Confessions*, 1862

62. *Bunch of Violets,*
Manet, 1872

tation. Like those lettered on the pamphlet in the portrait of Zola, they also serve as the picture's dedication and signature: 'To Mlle Berthe Morisot – E. Manet.' And since the lady in question was a close friend and informal pupil of Manet's, whom he portrayed in that year wearing a corsage of violets,[57] those in the still life must also reflect her taste. But since in the language of flowers the violet represented modesty and reserve, he may also have chosen them as a discreet comment on her personality, which Valéry later described as 'rare and reserved, . . . a personality whose grace and remoteness

combined to create an extraordinary charm'.[58] Further evidence of this willingness to employ flower symbolism on occasion is found in *Olympia* itself, in the large red flower she wears in her hair [63].

It has not been generally recognized as such, most scholars having preferred to see it as a silk bow. Even Manet's contemporaries were divided: one reviewer described Olympia as 'a young girl lying on a bed, having as her only apparel a bow of ribbon in her hair', and another as 'having borrowed from art no other ornament than a rose, with which she has dressed her tow-like hair'.[59] When examined closely, the object resembles a flower, rose-colored with deeper tones of rose and spots of purple, more clearly than a ribbon; and this resemblance is still more apparent in Manet's and Gauguin's copies of the picture [9, 14]. Moreover, throughout the early 1860s the fashion for ladies as well as courtesans was to wear flowers in their hair, either in a crown or bunch at the top or as a single blossom at the side, as here; ribbons were very rarely worn, and then only hanging loosely at the back.[60] What is unusual about Olympia's flower is its form, for despite its coloring it is clearly not a rose but an orchid, of which one half, containing the petals, is visible.[61] A vivid, showy species of tropical origin, it was difficult and expensive to cultivate in France, therefore an ideal emblem of the wealthy courtesan's taste for ostentation and luxury, like her jewelry, her satin slippers, and her Indian silk stole. It was in the same spirit that Cora Pearl, one of the most extravagant of contemporary cocottes, 'gave a supper party, strewed the orchids [Prince Napoleon had given her] over the floor and, dressed as a sailor, danced the hornpipe, followed by the cancan, over them'.[62] In fact the flower she wears in a contemporary photograph [64] may well be one of that species.

Olympia's flower had other meanings as well. Like the Negress, it was of exotic origin, suggesting the primitive passions of a tropical climate. And like the cat, it had an erotic connotation, evoking widely held beliefs about its aphrodisiac powers. From ancient times the orchid was thought to possess an ability to excite lust and to guarantee potency, probably because of the structural resemblance of certain

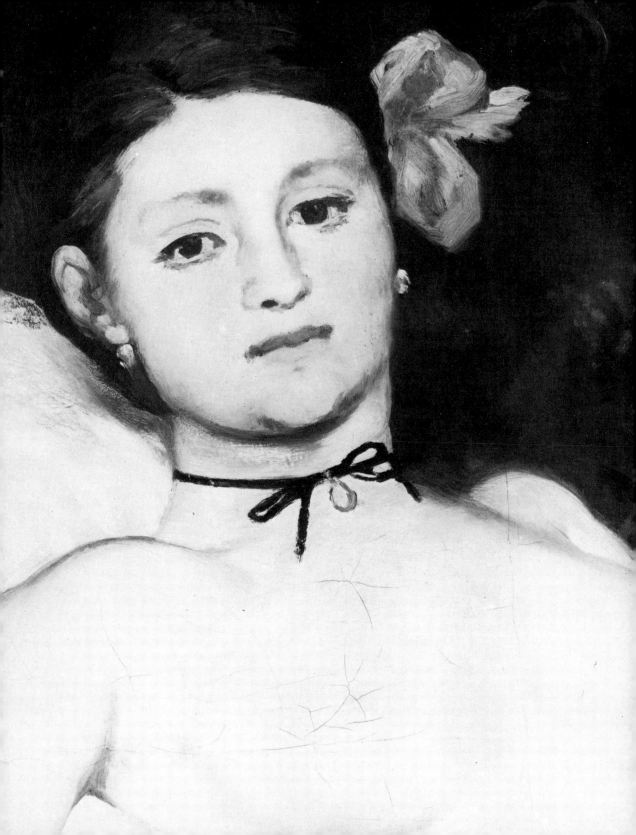

64. *Cora Pearl,*
Anatole Pougnet, *c.* 1860

types to the male, and of others to the female genitals. One type, shaped like a hand, was in fact known as the 'female orchid', and like Olympia's it is largely red.[63] That these beliefs were still current in Manet's time is evident from Rops' decision to base the flower symbolizing Lust in his frontispiece for Baudelaire's *Les Epaves* on a rare species of orchid, one so rare that he was obliged to ask the

publisher to send him 'a little sketch of the Orchis Satyrion, which is to represent Lust in this bouquet of pleasant flowers'.[64] In this respect too the poet's ideas on the symbolic significance of flowers seem closely related to Manet's in *Olympia*.

*

In its title however *Olympia* has no connection with Baudelaire, who referred to it simply as 'the painting of the nude woman, with the Negress and the cat'.[65] Other writers were less restrained: incensed by the noble yet clearly inappropriate classical name, they demanded, 'What is this Odalisque . . . who represents Olympia? Olympia? What Olympia?'[66] Unable to answer the question, scholars later pretended that the title had no significance and may not even have been Manet's invention. 'It is, for us, simply a sonorous sound', declared Rosenthal. 'Without attaching any precise meaning to it, Astruc may have made the fortunate discovery of those rhythmic syllables', added Jamot.[67] Meanwhile other scholars began to note the presence of an Olympia in *La Dame aux camélias*, where she is described as a 'blonde and thin' woman like Manet's and as 'undoubtedly the type of the courtesan without shame', though Bodkin's assumption that 'many who saw the picture on its first appearance must have connected the sitter with [her]' is not confirmed by contemporary criticism.[68] Subsequently several writers, Jamot and Mathey among them, repeated this observation, while continuing to maintain, without evidence, that the title is 'a literary man's discovery' and therefore 'must be attributed to Zacharie Astruc'.[69] Only Sandblad pointed out that Manet was capable of choosing it himself and in fact had been friendly with Dumas fils at the time of the play's first success, but like his predecessors he said little about the many other plays and tales in which the name had occurred.[70]

Olympe, the elegant demi-mondaine who becomes Armand's mistress toward the end of *La Dame aux camélias*, is indeed presented in the play, and still more vividly in the novel that preceded it, as 'the very type of the courtesan without shame, without heart, and

without intelligence', capable only of using her beauty for venal purposes.[71] (The scene of Armand's first intimacy with Marguerite bears an intriguing, but no doubt fortuitous, resemblance to Manet's picture: 'Her naked feet in satin slippers', Marguerite 'throws on the foot of the bed the lace garment she is wearing and lies down', while Armand sits before her, overwhelmed by her naked beauty, and the maid appears, carrying a midnight supper.)[72] If the novel, published on the eve of the 1848 revolution, had little success, the play was widely acclaimed four years later, and undoubtedly established Olympia as a familiar figure. But this was neither her last nor her most important appearance in the theater. In Augier's *Le Mariage d'Olympe*, a realistic response to Dumas' somewhat sentimental portrayal of the demi-monde, the heroine is a calculating, completely heartless *cocotte*, 'quite simply one of the most and the best kept women of Paris', whose ambition is to enter high society.[73] In Varin and de Biéville's *Ce que deviennent les roses*, a response in its turn to Augier's play, she has succeeded in that ambition and now, middle-aged and very wealthy, is exploited by younger men of similar qualities.[74] A decade later the same type appeared again in Augu's *Les Femmes sans nom* as 'la grande Olympe', a coarse, mercenary creature whom one of the other characters calls a Messalina.[75] Thus the name had a definite connotation on the French stage throughout the period of the creation and exhibition of Manet's picture, though no one seems to have remarked this at the time.

It had already been identified with such a type in earlier nineteenth-century fiction. In a story by Balzac, later incorporated into *La Muse du département*, a second story is told about an Olympia who lives in Renaissance Rome and is pictured first as a 'ravishing courtesan' who grows wealthy by corrupting the papacy and then as a cruel duchess who torments her husband by forcing him to witness her love affairs.[76] In choosing the name, Balzac may have had in mind Olympe Pelissier, a beautiful and intelligent courtesan who was Eugene Sue's mistress and had probably become his own shortly before he wrote the story.[77] But he may also have had an historical

model, Olimpia Maidalchini, the sister-in-law and paramour of Pope Innocent X and the real power behind his papacy. Extremely ambitious and insatiably greedy, she has been described in terms that suit Balzac's personage as well as Manet's: 'If by "courtesan" one means a woman who sees in love a means of satisfying her vanity, her egoism, or her cupidity, never would this term be better applied than to the face of this Donna Olimpia.'[78] Manet may in fact have been aware of her character quite apart from Balzac, since it is discussed in nineteenth-century biographies of his idol Velázquez, who supposedly painted her portrait on a visit to Rome.[79] In any event, he was certainly familiar, like Dumas fils before him, with the Olympia who plays such a remarkable role in Hoffmann's story 'The Sand Man'. One of the popular *Contes fantastiques*, which were enthusiastically received on their publication in French in 1830 and were adapted for the stage two decades later, it presented her as an ingeniously wrought mechanical doll, elegant and beautiful but coldly inhuman, who eventually drives the hero Nathaniel to self-destruction.[80] Therefore she was the ideal model for the image of Olympia as a fatal woman that appeared soon afterward in the plays of Dumas fils, Augier, and the others mentioned and, alone among paintings, in the work of Manet.

<div align="center">*</div>

These were by no means the only plays produced during the Second Empire that dealt with the courtesan in contemporary society. With its related themes, the notable rise in personal wealth and the equally notable decline in public morality, it was treated with increasing frequency and frankness in the Social Drama of the period.[81] One year after the success of *La Dame aux camélias*, Barrière and Thiboust produced *Les Filles de marbre* as a critique of it, depicting the *lorette* Marco as a heartless, mercenary creature who forces the sculptor Raphael to sacrifice his art, his family, and eventually himself. Two years later Dumas fils returned to the subject in *Le Demimonde*, introducing that term to describe the many women who, like

Suzanne, were at that moment achieving wealth through venality, then seeking respectability through marriage. Two years after that Feuillet carried the investigation further in *Dalila*, portraying in that figure a new social type, the *cocotte* who is beautiful and elegant, yet mercenary and promiscuous, and brings to ruin the composer who loves her. In the following decade, in Augier's *La Contagion* and Meilhac and Halévy's *Fanny Lear*, among others, she was pictured in a still more harshly realistic light as a threat to the very fabric of society. This was a significant change from the image of the courtesan in *La Dame aux camélias*, where Marguerite is eventually redeemed by her love and self-sacrifice, though her rival Olympe already announces the later type. As Dumas fils himself put it in 1867, '*La Dame aux camélias*, written fifteen years ago, could no longer be written today; not only would it no longer be true, it would not even be possible.'[82] For just as he had anticipated the heartless *cocotte* of the future in Olympe, so he had recalled the repentant sinner of the past in Marguerite.

The Romantic notion of the courtesan as still capable of love and redeemed by certain actions or traits was embodied in several plays of the July Monarchy and the Second Republic. In *Marion Delorme* Hugo presented the very type of the fallen woman who is ultimately rehabilitated by her love for an idealistic man; at the end she declares to Didier, 'Your love has made a virginity for me.'[83] In *Lucrèce Borgia* he depicted a notoriously immoral woman, but partly vindicated her through the love she bore her son; indeed he urged society to tolerate and forgive her kind as unfortunate victims. In *L'Aventurière* Augier portrayed the former courtesan Clorinde in more realistic terms as thoroughly venal and a threat to society, but eventually allowed her to obtain its pardon. These Romantic plays also differ from those of the Second Empire in the milieu they describe and the literary forms they employ: set in sixteenth-century Italy or seventeenth-century France, and written in verse in a traditional idiom, they lack the immediacy of the later works, which are situated in modern Paris and use a vernacular prose style that often

renders the coarseness of colloquial speech. Very much the same qualities distinguish the odalisques of Ingres and Delacroix and the courtesans in Couture's *Romans of the Decadence* from the prostitutes of Guys and Olympia herself, 'she who has the serious fault', Zola reminded his readers, 'of closely resembling young ladies of your acquaintance'.[84] The earlier artists and writers had removed the venal woman or slave to a remote setting, whether geographical or historical, the Near East or the Renaissance, thereby avoiding the disturbing realism that the later ones tried to achieve, then paid for in critical hostility. The censor's report on *La Dame aux camélias* in 1851 sounds exactly like the critics' comments on *Olympia* fourteen years later: 'It is a picture in which the choice of figures and the crudity of the colors go beyond the furthest limits of theatrical tolerance.'[85]

In addition to the drama and the novel, in which it also figured prominently, the *haute bicherie parisienne* of the 1860s was the subject of almost daily chronicles in the newspapers and magazines. Prevented by an authoritarian government from discussing religion and politics extensively, the press paid more attention to social life, reporting in detail on the appearance, behavior, theatrical performances, and financial affairs of the most notorious courtesans and keeping them constantly in the public's eye. Such was their fame, especially in the later years of the Empire, that photographs of them were featured in shop windows, alongside those of royalty and statesmen. The ladies themselves, ostentatiously dressed, appeared at the fashionable racetracks, in boxes at the Italian opera, and at the openings of new plays, of which they themselves were often the subject and their friends the stars. Respectable women soon began to imitate their dress, their manners, and their speech so closely that they were difficult to distinguish from the *cocottes*.[86] As the caption of a lithograph in *Le Charivari* put it in 1864: 'What difference is there at first sight between a *grande dame* and a *petite dame*? They dress alike; they go to the Bois [de Boulogne] at the same time; they receive the same gentlemen. Their carriages are equally elegant and

each wears as much false hair as the other. Very strange indeed!'[87]
Almost exactly contemporary with *Olympia*, the lithograph also
resembles it as an image [65], showing the coldly beautiful courtesan,

Quelle différence y a-t-il à première vue, entre une grande dame et une petite dame ?
leur costume est le même, elles vont au bois à la même heure, elles reçoivent les
mêmes Messieurs, elles ont le même nombre de ressort à leurs voitures et autant de
faux cheveux l'une que l'autre. Étrange, étrange!

with a flower in her hair and jewels at her wrists and throat, half
reclining and staring arrogantly, though Manet's figure is naked
and receives a gentleman's bouquet, while the *Charivari* figure is
dressed and receives the gentleman himself.

The Second Empire was indeed one of the golden ages of the courtesan, whose prosperity alarmed as well as fascinated many observers. In 1867 Dumas fils warned that the 'formidable throng known as "kept women" . . . is growing and expanding so much that it will break customs and laws, just as Paris, its fatherland, has broken its barriers'.[88] His reference to the recent expansion of the city was apt, for like the courtesan Paris, or rather its upper classes, had experienced an extraordinary prosperity.[89] From industrial development, railroad construction, and financial speculation, immense fortunes had been made within a decade, and just as Paris had become the center of these managerial activities, so it had become the pleasure capital of the world. Moreover, the railroads that brought unprecedented wealth also brought a previously unknown social mobility, helping to dissolve traditional communal and domestic ties and inundating Paris with rich but gullible provincials and foreigners, all bent on pursuing pleasure rapidly and lavishly. In this the courtesan could be useful: naturally extravagant, and driven to further extravagance by her *nouveau-riche* lovers, who saw in her a 'living display of their prosperity',[90] she wasted fortunes on town-houses, carriages, clothing, and jewelry and entertained on a no less princely scale. As Alphonse de Rothschild remarked to one of her kind, 'When I return home after leaving you, my own town-house seems to me a hovel.'[91] In the costliest of all such mansions, built on the Champs-Elysées for three million francs, Baudry decorated a ceiling with pictures of the world's famous lovers, from Cleopatra to La Paiva, the mistress of the house.[92] It was Baudry, we recall, whose painting *The Pearl and the Wave* had struck Proudhon at the Salon of 1863 as the very image of prostitution.

La Paiva, the mistress of an immensely rich German mine owner, was one of the dozen or so most sought-after and widely publicized courtesans known as *la garde*, who epitomized the extravagance of their profession and established its image.[93] Among the others were Adèle Courtois, a model of fashionable elegance whose manners and

appearance were imitated; Anna Deslions, a favorite of the gentle-
men in high society who had fortunes to squander; Giulia Barucci, a
once-poor Italian girl with jewelry later worth over a million francs;
and Cora Pearl, an English woman whose 'talent for voluptuous
eccentricities' brought great wealth. These are the creatures who, as
much as Victorine Meurend and the *Venus of Urbino*, were the
models for *Olympia*. Contemporary descriptions of some of them
sound in fact like a description of Manet's subject. Marguerite
Bellanger, the Emperor's mistress, was 'below average in size, slight,
thin, almost skinny, blonde, fine, very pretty, with beautiful elo-
quent eyes', and Juliette Beau, also one of *la garde*, was 'thin, refined,
a little naïve, with a skin of a striking whiteness, . . . [and] a small,
well-proportioned body, close-knit in all its parts'.[94] It was pre-
cisely this image of the courtesan that Manet seized on, at the
moment of her greatest power, wealth, and notoriety, the only
moment indeed when an artist as responsive as he to the significance
of contemporary social types could create such an image on a
monumental scale.

Zola too must have recognized the uniqueness of that moment,
for when a few years later he planned a novel about the fatal power
of the courtesan who is 'less a woman than an idol', he knew it must
be set toward the end of the Second Empire, and when a decade
later he wrote that novel he went to great lengths to gather informa-
tion on those who had formed *la garde*, interviewing some like Anna
Deslions and learning about others from friends and memoirs.[95] In
creating from these sources the symbolic type of Nana, he came close
to achieving in his medium what Manet had achieved in his own
some sixteen years earlier, although ironically it was Zola who had
argued most eloquently at the time against finding any symbolic
meaning in *Olympia*. It is only now, when Zola's view is rejected and
the picture is seen in its historical as well as its artistic context, that
the extraordinary richness of its meaning becomes evident.

Notes

1. CRITICAL AND ARTISTIC RESPONSES (*pages 14–41*)

1. The best account is in T. Duret, *Histoire de Edouard Manet et de son oeuvre*, Paris, 1906, pp. 49–56.

2. J. Claretie in *Le Figaro*, 20 June 1865; trans. G. H. Hamilton, *Manet and His Critics*, New Haven, 1954, p. 73.

3. Woodcut by Cham in *Le Charivari*, 14 May 1865; see M. Curtiss, 'Manet Caricatures: *Olympia*', *Massachusetts Review*, VII, 1966, pp. 725–52, no. 3; also nos. 4, 23.

4. Colored lithograph in A. Gill, *Salon pour rire*, Paris, 1868; Curtiss, no. 17. The allusions are to Courbet's *Woman with a Parrot* and Whistler's *At the Piano*.

5. E. Fillonneau in *Le Moniteur des arts*, May 1865; trans. Hamilton, pp. 71–2.

6. Letter of May 1865; cited A. Tabarant, *Manet et ses oeuvres*, Paris, 1947, p. 110.

7. Duret, pp. 57–9.

8. Published in *Le Charivari*, 19 June 1865; Delteil 3446; see Curtiss, no. 24.

9. Hamilton, pp. 67–8.

10. Curtiss, p. 728.

11. C. Clément in *Le Journal des débats*, 21 May 1865, and P. de Saint-Victor in *La Presse*, 28 May 1865; trans. Hamilton, pp. 70–71.

12. J. Claretie in *L'Artiste*, 15 May 1865; trans. Hamilton, p. 73.

13. T. Gautier in *Le Moniteur universel*, 24 June 1865; trans. Hamilton, pp. 74–5.

14. G. Privat, *Place aux jeunes! Salon de 1865*; trans. Hamilton, p. 77.

15. T. Thoré, 'Le Salon de 1865'; *Salons de W. Bürger, 1861 à 1868*, 2 vols., Paris, 1870, II, p. 221.

16. See J. C. Sloane, *French Painting between the Past and the Present*, Princeton, 1951, pp. 23–34.

17. P. de Saint-Victor in *La Semaine*, 4 Apr. 1847; trans. F. L. Klagsbrun, 'Thomas Couture and *The Romans of the Decadence*', M.A. thesis, New York University, 1958, pp. 17–18. Also T. Gautier, *Le Salon de 1847*; trans. ibid.

18. Klagsbrun, pp. 19, 38–9.

19. Note 15, above. His earlier charges appeared in *L'Indépendance belge*, 15 June 1864; trans. Hamilton, pp. 60–62.

20. P. de Saint-Victor in *Le Moniteur universel*, July 1871; reprinted A. Houssaye, *Lucie: Histoire d'une fille perdue*, Paris, n.d. [1873], p. 318.

21. E.g. in *La Tribune*, 6 Dec. 1868; E. Zola, *Oeuvres complètes*, ed. H. Mitterand, 15 vols., Paris, 1966–9, XIII, p. 207.

22. In *L'Evénement*, 7 May 1866; E. Zola, *Salons*, ed. F. W. Hemmings and R. J. Niess, Geneva, 1959, pp. 64–9; partly trans. Hamilton, pp. 84–7.

23. Letter of 7 May 1866; cited P. Jamot and G. Wildenstein, *Manet*, 2 vols., Paris, 1932, I, p. 81. See I. Ebin, 'Manet and Zola', *Gazette des Beaux-Arts*, XXVII, 1945, pp. 357–78.

24. In *La Revue du xixᵉ siècle*, 1 Jan. 1867; Zola, *Salons*, pp. 83–103, especially pp. 97–8; partly trans. Hamilton, pp. 98–9.

25. F. W. Hemmings, 'Emile Zola critique d'art', in Zola, *Salons*, pp. 9–42. G. Picon, 'Zola's Painters', *Yale French Studies*, no. 42, 1969, pp. 126–42.

26. In *La Cloche*, 29 June 1870; Zola, *Oeuvres complètes*, X, p. 936. See also E. Zola, *Les Rougon-Macquart*, ed. A. Lanoux and H. Mitterand, 5 vols., Paris, 1960–67, II, pp. 1653–7.

27. W. Hofmann, *Nana: Mythos und Wirklichkeit*, Cologne, 1973, pp. 29–31. The black cat that plays an important symbolic role in another early novel, *Thérèse*

Raquin (1867), may also have been inspired by *Olympia*'s.

28. Letter of 2 Jan. 1867; cited Jamot-Wildenstein, I, p. 82.

29. J. de Biez, *Edouard Manet*, Paris, 1884, p. 8. He must have met Manet about 1880.

30. A. Retté, *Le Symbolisme: Anecdotes et souvenirs*, 1903; cited *Centenaire de l'Impressionnisme*, Grand Palais, Paris, 1974, p. 117.

31. T. Reff, 'Manet's Portrait of Zola', *Burlington Magazine*, CXVII, 1975, pp. 35–44, on which the following is based.

32. L. Rosenthal, *Manet aquafortiste et lithographe*, Paris, 1925, pp. 130–31. The view he rejects is that of A. Fontaine, *Essai sur le principe et les lois de la critique d'art*, Paris, 1903, p. 322.

33. Jamot-Wildenstein, I, pp. 28–9. Already stated in P. Jamot, 'Manet and the *Olympia*', *Burlington Magazine*, L, 1927, p. 31.

34. E. Waldmann, *Edouard Manet*, Berlin, 1923, pp. 23–8.

35. G. Severini, *Edouard Manet*, Rome, 1924, pp. 15–17.

36. R. Rey, *Manet*, trans. E. B. Shaw, New York, 1938, p. 13. A similar view in P. Colin, *Edouard Manet*, Paris, 1932, p. 25.

37. M. Florisoone, *Manet*, Monaco, 1947, p. xxiv.

38. F. Mathey, *Olympia: Manet*, Paris, 1948, p. 14.

39. L. Venturi, *Impressionists and Symbolists*, trans. F. Steegmuller, New York, 1950, pp. 6–7. Similar statements in M. Bex, *Manet*, New York, 1948, p. 11, and J. Leymarie, *Manet*, Paris, 1951, p. 7.

40. G. Bataille, *Manet*, trans. A. Wainhouse and J. Emmons, New York, 1955, pp. 66–7. P. Valéry, 'The Triumph of Manet', *Degas, Manet, Morisot*, trans. D. Paul, New York, 1960, pp. 108–9; published 1932.

41. *Exposition des oeuvres d'Edouard Manet, Catalogue*, Ecole Nationale des Beaux-Arts, Paris, 1884, Preface; Zola, *Salons*, pp. 256–62.

42. L. Gonse, 'Manet', *Gazette des Beaux-Arts*, XXIX, 1884, p. 140.

43. J.-K. Huysmans, annotated copy of catalogue cited note 41, above; in Bibliothèque Nationale, Cabinet des Estampes. Idem, 'Carnet secret', ed. P. Lambert, *Le Figaro littéraire*, 7–8 July 1964; comment made in 1889.

44. G. Geffroy, 'Olympia', *La Vie artistique*, première série, Paris, 1892, pp. 17–18. A similar view already stated in E. Bazire, *Manet*, Paris, 1884, pp. 26–7.

45. Duret, pp. 53–4.

46. A. Proust, 'L'Art d'Edouard Manet', *Le Studio*, XXI, 1901, p. 74.

47. J. Meier-Graefe, *Impressionisten*, Munich and Leipzig, 1907, pp. 78–84, and *Edouard Manet*, Munich, 1912, pp. 133–49. A similar view in H. von Tschudi, *Edouard Manet*, Berlin, 1902, pp. 17–19.

48. J. Laran and G. Le Bas, *Edouard Manet*, Introduction by L. Hourticq, Philadelphia and London, 1912, p. xi.

49. N. G. Sandblad, *Manet: Three Studies in Artistic Conception*, Lund, 1954, pp. 94–100.

50. J. Richardson, *Edouard Manet: Paintings and Drawings*, London, 1958, pp. 22–4.

51. Hamilton, pp. 78–80.

52. T. Reff, 'The Meaning of Manet's *Olympia*', *Gazette des Beaux-Arts*, LXIII, 1964, pp. 111–22.

53. G. Needham, 'Manet, *Olympia*, and Pornographic Photography', *Art News Annual*, XXXVIII, 1972, pp. 81–9.

54. Hofmann, *Nana*, chap. v, vi.

55. Hamilton, p. 115. See G. Riat, *Gustave Courbet*, Paris, 1906, pp. 234–42.

56. Reported by A. Wolff in *Le Figaro*, 1 May 1883; cited Rosenthal, p. 127.

57. J. C. Harris, *Edouard Manet: Graphic Works*, New York, 1970, nos. 52, 53.

58. Rosenthal, p. 134, note 1. See Sale, Coll. Alexandre Dumas, Hôtel Drouot, 12–13 May 1892, no. 68, with illustration.

59. L. Venturi, *Cézanne, son art, son oeuvre*, 2 vols., Paris, 1936, nos. 106, 225, 882–4, 886.

60. Like the copy he made for that purpose of his portrait of Manet; Mme Fantin-Latour, *Catalogue de l'oeuvre complet de Fantin-Latour*, Paris, 1911, no. 1135, and Art Institute of Chicago, *Annual Report*, 1967–8, p. 33.

61. The fullest account is in G. Geffroy, *Claude Monet*, Paris, 1922, pp. 123–54.

62. See P. Gauguin, *Lettres à sa femme et à ses amis*, ed. M. Malingue, Paris, 1946, pp. 193–4, and G. Wildenstein, *Gauguin*, Paris, 1964, no. 413, quoting Rotonchamp's memoir.

63. R. Huyghe, *Le Carnet de Paul Gauguin*, 2 vols., Paris, 1952, I, pp. 117–18, and II, pp. 186–7; there is also a caricature of Manet's *Fifer*.

64. Wildenstein, no. 542. R. Muther, *The History of Modern Painting*, trans. A. C. Hillier, 3 vols., London, 1896, II, pp. 734–5.

65. P. Daix and G. Boudaille, *Picasso: The Blue and Rose Periods*, Greenwich (Conn.), 1967, no. D. IV. 7.

66. A. H. Barr, Jr., *Picasso: Fifty Years of His Art*, New York, 1946, p. 284. H. Tietze, *Tizian: Leben und Werk*, 2 vols., Vienna, 1936, II, pl. 181.

67. R. Rosenblum, 'The *Demoiselles d'Avignon* Revisited', *Art News*, LXII, no. 4, Apr. 1973, pp. 45–8.

68. P. Courthion, *Georges Rouault*, New York, 1961, p. 164; for similar subjects, see pp. 138–9.

69. Sale, Georges Rouault, Graphik und illustrierter Bücher, Klipstein and Kornfeld, Bern, 9 June 1966, nos. 102–15, especially no. 112.

70. M. Loreau, *Catalogue des travaux de Jean Dubuffet*, 21 vols., Paris, 1964–70, VI, no. 85.

71. *Pop Art Redefined*, ed. J. Russell and S. Gablik, New York and Washington, 1969, p. 15, with photographs.

72. *Larry Rivers, 1965–1970*, Marlborough Gallery, New York, 1970–1, no. 33; reproduced in color.

73. For illustrations, see *Arts Magazine*, XLVIII, no. 5, Feb. 1974, p. 45, and *The Times*, 19 Dec. 1973, p. 11, respectively. The latter reference I owe to John Fleming.

2. PICTORIAL SOURCES AND STRUCTURE (*pages 42–87*)

1. J.-E. Blanche, *Manet*, Paris, 1924, pp. 34–5 on Mme Manet. Biez, p. 21, and Bazire, pp. 26–7 on Baudelaire.

2. Letter to Manet, 11 May 1865; C. Baudelaire, *Correspondance générale*, ed. J. Crépet, 6 vols., Paris, 1947–53, V, p. 97.

3. Hamilton, pp. 151–2.

4. Richardson, p. 23; the quotation is from C. Baudelaire, *The Painter of Modern Life and Other Essays*, trans. J. Mayne, London, 1964, p. 28. See also L. Nochlin, 'The Invention of the Avant-Garde', *Art News Annual*, XXXIV, 1968, p. 16: *Olympia* is 'a monumental and ironic put-on, a *blague*'.

5. Ch. 2, note 2, above.

6. A. Proust, *Edouard Manet: Souvenirs*, Paris, 1913, pp. 47, 80 on *Olympia*. Duret, p. 44 on the *Déjeuner sur l'herbe*.

7. 'When, tired of dreaming, Olympia awakens / Spring enters on the arm of the mild black messenger; / She is the slave who, like the amorous night, / Comes to adorn with flowers the day delightful to behold: / The august young woman in whom ardour is ever wakeful.' From 'La Fille des Iles'; cited in entirety in Meier-Graefe, *Manet*, pp. 134–6.

8. E. Chesneau in *Le Constitutionnel*, 16 May 1865; trans. Hamilton, p. 72.

9. C. Baudelaire, 'Le Salon de 1859'; *Art in Paris, 1845–1862*, trans. J. Mayne, London, 1965, pp. 149–51.

10. Jamot-Wildenstein, no. 113. See Hamilton, p. 66.

11. Jamot-Wildenstein, no. 83 (fragment of *Incident*), no. 85. See G. Mauner, 'Manet, Baudelaire, and the Recurrent Theme', *Perspectives in Literary Criticism*, ed. J. Strelka, University Park and London, 1968, pp. 251–2.

12. Ch. 1, note 15, above. See A. de Leiris, 'Manet's *Christ Scourged* and the Problem of His Religious Paintings', *Art Bulletin*, XLI, 1959, pp. 198–201.

13. C. Blanc, *Histoire des peintres de toutes les écoles: Ecole vénitienne*, Paris, 1868, 'Titien Vecelli', p. 15. Published serially in 1855; see T. Reff, 'Manet and Blanc's *Histoire des peintres*', *Burlington Magazine*, CXII, 1970, pp. 456–8.

14. J. Northcote, *The Life of Titian*, 2 vols., London, 1830, II, p. 233. C. Ridolfi, *Le Maraviglie dell' arte*, Venice, 1648, pp. 161–2.

15. Jamot-Wildenstein, nos. 30, 36. See Sandblad, pp. 37–44.

16. G. Bazin, 'Manet et la tradition', *L'Amour de l'art*, XIII, 1932, pp. 159–60.

17. E. Chesneau, *L'Art et les artistes modernes en France et en Angleterre*, Paris, 1864, p. 190, note 1.

18. Geffroy, 'Olympia', p. 15. L. Bénédite, 'La Collection Caillebotte au Musée du Luxembourg', *Gazette des Beaux-Arts*, LXXX, 1897, p. 254.

19. Hofmann, *Nana*, pp. 27–8.

20. A. Boime, *The Academy and French Painting in the Nineteenth Century*, London, 1971, pp. 71–2. E. Forssman, *Venedig in der Kunst und im Kunsturteil des 19. Jahrhunderts*, Stockholm, 1971, pp. 161–2.

21. T. Couture, *Méthode et entretiens d'atelier*, Paris, 1867, p. 131.

22. Jamot-Wildenstein, nos. 3–6. See J. Alazard, 'Manet et Couture', *Gazette des Beaux-Arts*, XXXV, 1949, pp. 213–18, and [T. Borenius], 'Manet and Venice', *Burlington Magazine*, LXXXVII, 1945, pp. 185–6.

23. Bataille, pp. 68–9.

24. D. Farr, *William Etty*, London, 1958, no. 306, with reference to Gilchrist. G. Wildenstein, *Ingres*, London, 1956, no. 149. Forssman, fig. 74 for Lenbach.

25. Boime, p. 130 and fig. 116.

26. Jamot-Wildenstein, nos. 63, 110, 311, respectively. See R. Huyghe, 'Manet, peintre', *L'Amour de l'art*, XIII, 1932, p. 177.

27. A. Dumas, *Michel-Ange, suivi de Titien Vecelli*, Brussels, 1844, pp. 143–4.

28. C. Léger, *Courbet*, Paris, 1929, p. 90. On the history of this type, see F. Saxl, 'A Humanist Dreamland', *Lectures*, 2 vols., London, 1957, I, pp. 215–27.

29. Color lithograph in *La Chronique illustrée*, 6 May 1872; see C. Léger, *Courbet selon les caricatures et les images*, Paris, 1920, p. 105. On the painting, see Riat, pp. 272–3, 333–5.

30. J. J. Baric, *Un Tour au Salon: Exposition des beaux-arts de 1863*, Paris, 1863, p. 1.

31. Published in *Le Charivari*, 10 May 1865; Delteil 3440.

32. T. Thoré, 'Le Salon de 1863'; *Salons de W. Bürger*, I, pp. 373–4.

33. P.-J. Proudhon, *Du Principe de l'art et de sa destination sociale*, Paris, 1865, pp. 257–8.

34. T. Gautier, *Italie*, Paris, 1855, pp. 308–10. E. and J. de Goncourt, *L'Italie d'hier*, Paris, 1894, pp. 122–3; written 1855–6.

35. H. Taine, *Voyage en Italie*, 2 vols., Paris, 1865, II, pp. 161–2. See also N. Hawthorne, *French and Italian Note-Books*, 2 vols., London, 1871, II, p. 9; written 1858.

36. T. Gautier, *Mademoiselle de Maupin*, Paris, 1966, p. 104; published 1835.

37. T. Reff, 'The Meaning of Titian's *Venus of Urbino*', *Pantheon*, XXI, 1963, pp. 359–66.

38. *Grand dictionnaire universel du xixe siècle*, ed. P. Larousse, Paris, n.d. [1866–76], s.v. 'Vénus couchée'. M. Thausing, 'Tizian und die Herzogin Eleanora von Urbino', *Zeitschrift für bildende Kunst*, XIII, 1878, p. 306.

39. Dumas, pp. 206–24.

40. Stendhal [H. Beyle], 'Souvenirs d'égotisme', *Oeuvres intimes*, ed. H. Martineau, Paris, 1961, pp. 1407–8; written 1832, published 1892. See Hofmann, *Nana*, p. 184, note 3.

41. G. H. Hamilton, 'Is Manet Still "Modern"?' *Art News Annual*, XXXI, 1966, p. 160.

42. Valéry, p. 109.

43. C. Baudelaire, *Oeuvres posthumes*, ed. J. Crépet and C. Pichois, 3 vols., Paris, 1952, III, p. 11, and II, p. 58, respectively.

44. E. and J. de Goncourt, *Journal*, entry of 11 Apr. 1864; cited Sandblad, p. 98. Zed [A. de Maugny], *Le Demi-monde sous le Second Empire*, Paris, n.d. [1892], pp. 36–7.

45. E. Chesneau in *Le Constitutionnel*, 16 May 1865; cited Tabarant, p. 107. A recent reading of the hand as masturbating is incorrect, since the index finger is not 'absent' but visible beside the others; see C. Van Emde Boas, 'Le Geste d'*Olympia*', *Livre jubilaire offert au docteur Jean Dalsace*, Paris, 1966, p. 132.

46. J. Canaday, *Mainstreams of Modern Art*, New York, 1961, p. 167. For the opposite interpretation, see M. Fried, 'Manet's Sources', *Artforum*, VII, no. 7, Mar. 1969, p. 69, note 27; also T. Reff, '"Manet's Sources": A Critical Evaluation', *Artforum*, VIII, no. 1, Sept. 1969, p. 48, note 27.

47. E. Fuchs, *Illustrierte Sittengeschichte*, 6 vols., Munich, 1909–12, III, pp. 68, 114.

48. Ch. 1, notes 5, 13, above.

49. E.g., in J. A. Crowe and G. B. Cavalcaselle, *The Life and Times of Titian*, 2 vols., London, 1881, I, pp. 389–91.

50. E. Wind, '"Borrowed Attitudes" in Reynolds and Hogarth', *Journal of the Warburg Institute*, II, 1938–9, pp. 182–5.

51. H. Rosenberg, *Arshile Gorky*, New York, 1962, pp. 53–62.

52. S. Kracauer, *Offenbach and the Paris of His Time*, London, 1937, pp. 161–73 on *Orphée* (1858), pp. 228–35 on *Hélène* (1864).

53. Baudelaire, *Painter of Modern Life*, p. 14; written 1859–60, published 1863.

54. L. B. Hyslop and F. E. Hyslop, 'Baudelaire and Manet: A Re-Appraisal', *Baudelaire as a Love Poet and Other Essays*, ed. L. B. Hyslop, University Park and London, 1969, pp. 89, 100, 110. See also Hofmann, *Nana*, pp. 35, 39.

55. *Grand dictionnaire universel du xixe siècle*, s.v. 'Nymphe'. On the derivation, see Sandblad, pp. 90–92.

56. Ch. 1, note 43, above.

57. J. Meier-Graefe, *Manet und sein Kreis*, Berlin, 1902, p. 16. C. Mauclair, *De l'amour physique*, Paris, n.d. [1912], p. 139. Jamot, 'Manet and *Olympia*', pp. 31–5. T. Bodkin, 'Manet, Dumas, Goya, and Titian', *Burlington Magazine*, L, 1927, pp. 166–7.

58. P. Gassier and J. Wilson, *The Life and Complete Work of Francisco Goya*, New York, 1971, p. 152 and nos. 743–4. C. Yriarte, *Goya*, Paris, 1867, pp. 88–9.

59. T. Gautier, *Voyage en Espagne*, Paris, 1859, pp. 115–

24. Baudelaire, letter to Nadar, 14 May 1859; *Correspondance*, II, pp. 310–11.

60. Ch. 2, note 59, above.

61. Letter to Ancelle, 8 Feb. 1865; *Correspondance*, V, p. 28.

62. Letter to Fantin-Latour, Aug. 1865; cited E. Moreau-Nélaton, *Manet raconté par lui-même*, 2 vols., Paris, 1926, I, pp. 71–2.

63. Letter to Astruc, 17 Sept. 1865; cited *Beaux-Arts*, 16 Mar. 1943, p. 1.

64. Letter to Thoré, 20 June 1864; trans. Hamilton, pp. 62–3.

65. *Manet and Spain*, ed. J. Isaacson, Museum of Art, University of Michigan, Ann Arbor, 1969, no. 21. See Jamot-Wildenstein, no. 63.

66. B. Farwell, 'Manet's *Espada* and Marcantonio', *Metropolitan Museum Journal*, II, 1969, pp. 204–6.

67. F. J. Sánchez Cantón, *The Life and Works of Goya*, trans. P. Burns, Madrid, 1964, pp. 74–5. N. Maclaren and A. Braham, *National Gallery Catalogues: The Spanish School*, London, 1970, pp. 125–9.

68. W. Hofmann, *The Earthly Paradise*, trans. B. Battershaw, New York, 1961, p. 350.

69. J. Lopez-Rey, *Goya's Caprichos*, 2 vols., Princeton, 1953, I, pp. 3–11. See especially pls. 5, 15, 31 of the *Caprichos*; ibid., II, figs. 94, 115, 149, respectively.

70. A. de Leiris, *The Drawings of Edouard Manet*, Berkeley and Los Angeles, 1969, no. 189. On its relation to other *Olympia* studies, ibid., pp. 61–2, and Tabarant, p. 55.

71. Harris, nos. 45, 57; based on *Caprichos*, pls. 27, 15, respectively. For the emblematic design, see Ch. 3, note 6, below.

72. G. Geffroy, *Constantin Guys: L'Historien du Second Empire*, Paris, 1904, p. 150. See the drawings reproduced, with contemporary photographs of prostitutes and excerpts from Baudelaire's *Painter of Modern Life*, in A. d'Eugny and R. Coursaget, *Au Temps de Baudelaire, Guys et Nadar*, Paris, 1945, pp. 136–49.

73. Tabarant, p. 370. Jamot-Wildenstein, no. 426.

74. Baudelaire, *Painter of Modern Life*, p. 37.

75. R. Ricatte, *La Genèse de 'La Fille Elisa'*, Paris, 1960, pp. 143–53.

76. De Leiris, *Drawings of Manet*, no. 193.

77. M. Serullaz, *Mémorial de l'Exposition Eugène Delacroix*, Paris, 1963, nos. 99, 201, 363, respectively. See de Leiris, *Drawings of Manet*, p. 18.

78. Jamot-Wildenstein, nos. 1, 2. Proust, *Manet: Souvenirs*, pp. 23–4.

79. De Leiris, *Drawings of Manet*, no. 191; called 'second version'.

80. ibid., no. 190; called 'first version'.

81. Bibliothèque Nationale, Cabinet des Estampes, Dc. 208c; also in ibid., Za. 133, as based on a drawing by Henri Decaisne, on whom see Proust, *Manet: Souvenirs*, pp. 13–14. Fried, pp. 42–3, cites a lithograph by Achille Deveria, but it shows the composition reversed; see Reff, 'Manet's Sources', pp. 47–8.

82. J.-J. Grandville, *Scènes de la vie privée et publique des animaux*, texts by P.-J. Stahl, *et al.*, 2 vols., Paris, 1842, II, pp. 165–92.

83. De Leiris, *Drawings of Manet*, nos. 194, 195. Tabarant, p. 76, denies their relation to *Olympia*, and cites instead a pencil drawing formerly in Degas' collection. But the latter is clearly a study for the etching after *Olympia*; see Sale, Salon Bollag, G. and L. Bollag, Zurich, 3 Apr. 1925, no. 137 and pl. 27.

84. Proust, 'L'Art d'Edouard Manet', p. 74. Bénédite, p. 256.

85. Klagsbrun, pp. 40–43. Wildenstein, *Ingres*, no. 93.

86. Mathey, pp. 6–8 and fig. 2.

87. Jamot-Wildenstein, no. 36. See Sandblad, pp. 33–6.

88. E. W. Longfellow, 'Reminiscences of Thomas Couture', *Atlantic Monthly*, Aug. 1883; cited J. Seznec, 'The *Romans of the Decadence* and Their Historical Significance', *Gazette des Beaux-Arts*, XXIV, 1943, p. 222.

89. Ch. 1, note 17, above. Also T. Thoré, *Le Salon de 1847*, Paris, 1847, p. 37.

90. *Thomas Couture, sa vie, son oeuvre . . . par lui-même et par son petit-fils*, Paris, 1932, pp. 12–13, with illustrations.

91. De Leiris, *Drawings of Manet*, no. 196. C. Oulmont, 'An Unpublished Water-Colour Study for Manet's *Olympia*', *Burlington Magazine*, XXII, 1912, pp. 44–7.

92. Ch. 1, notes 14, 43, above.

93. De Leiris, *Drawings of Manet*, no. 197. Both studies reproduced in color in K. Martin, *Edouard Manet: Water-Colours and Pastels*, London, 1959, pls. 4, 5.

94. Sandblad, pp. 99–100. Richardson, p. 15.

95. J. M. Kloner, 'The Influence of Japanese Prints on Edouard Manet and Paul Gauguin', Ph.D. dissertation, Columbia University, 1968, pp. 131–4. Boime, pp. 29–30, 72.

96. Reff, 'Manet's Portrait of Zola', p. 39 and fig. 33.

97. A. Scharf, *Art and Photography*, London, 1969, pp. 40–41. On Manet's use of photographs as documents, ibid., pp. 42–9.

98. Ch. 1, note 53, above.

99. Baudelaire, 'Le Salon de 1859', p. 153. Scharf, pp. 130–34.

100. F. A. Trapp, 'The Art of Delacroix and the Camera's Eye', *Apollo*, LXXXIII, 1966, pp. 278–88.

101. G. Ovenden and P. Mendes, *Victorian Erotic Photography*, New York and London, 1973, pp. 22, 44, 47–9.

102. Zola, *Salons*, pp. 91, 97; trans. Hamilton, pp. 93, 99. See also *Salons*, p. 86: 'He confessed that he adores society and finds secret pleasures in the perfumed and luminous delicacies of evening parties.'

103. G. Hopp, *Edouard Manet: Farbe und Bildgestalt*, Berlin, 1968, pp. 26–33. G. Jedlička, *Edouard Manet*, Zurich, 1941, pp. 74–7.

104. Harris, no. 56.

105. Letter of 28 June 1868; cited M. Guérin, *L'Oeuvre gravé de Manet*, Paris, 1944, no. 51. For the poem, see *Sonnets et eaux-fortes*, Paris, 1869, unpaged.

106. Tabarant, p. 55. De Leiris, *Drawings of Manet*, pp. 61–2. *Edouard Manet*, ed. A. C. Hanson, Phildelphia Museum of Art and Art Institute of Chicago, 1966–7, p. 73.

107. Jamot-Wildenstein, no. 237 *bis*, and I, pp. 32–3.

108. It is evoked in thinly disguised fictional form in P. Alexis, *Madame Meuriot: Moeurs parisiennes*, Paris, 1891, pp. 291–326.

109. Blanche, pp. 35–6.

110. E. Lepelletier, *Paul Verlaine, sa vie, son oeuvre*, Paris, 1907, p. 170; also ibid., pp. 171–9, and Tabarant, pp. 227–30, 238–40.

111. Jamot-Wildenstein, no. 265. Tabarant, pp. 238, 300.

112. A. Barrère, *Argot and Slang*, London, 1887, s.v. 'Grue'. *Dictionnaire érotique moderne*, s.v. 'Grue'.

113. From P. Hadol, 'La Ménagerie Impériale', 1871; see S. Lambert, *The Franco-Prussian War and the Commune in Caricature*, London, 1971, no. 6.

114. Jamot-Wildenstein, no. 275. Tabarant, pp. 299–300.

115. J.-K. Huysmans in *L'Artiste*, 13 May 1877; cited Tabarant, pp. 305–6. Manet, letter to Zola, Aug. 1876; cited Zola, *Rougon-Macquart*, II, p. 1663.

116. Ch. 1, note 27, above.

3. LITERARY SOURCES AND CONTENT (*pages 88–118*)

1. Zola, *Salons*, p. 91; trans. Hamilton, p. 94.

2. A. de Leiris, 'Baudelaire's Assessment of Manet', *Hommage à Baudelaire*, Art Department, University of Maryland, College Park, 1968, p. 7. Jamot, 'Manet and Olympia', p. 31.

3. Hyslop and Hyslop, *passim*. P. Rebeyrol, 'Baudelaire et Manet', *Les Temps modernes*, V, 1949, pp. 707–25.

4. Hamilton, pp. 29–30, 40.

5. C. Baudelaire, *Les Fleurs du Mal*, ed. J. Crépet and G. Blin, Paris, 1950, p. 495; present whereabouts unknown.

6. Harris, no. 61, drawing on proof of second state. C. Pichois and F. Ruchon, *Iconographie de Charles Baudelaire*, Geneva, 1960, no. 46; incorrectly identified as the other drawing. See F. Nordström, 'Baudelaire and Dürer's *Melencolia I*: A Study of a Portrait of Baudelaire by Manet', in P. Bjurström, *et al.*, *Contributions to the History and Theory of Art*, Uppsala, 1967, pp. 148–60.

7. Ch. 2, note 2, above.

8. For the poems cited, see C. Baudelaire, *The Flowers of Evil*, trans. W. Aggeler, Fresno, 1954, nos. cxii, xxix, xxviii, lxi, xx, respectively. 'And yet one sees from the graceful slimness / Of the angular shoulders, / The haunches slightly sharp, and the waist sinuous / As a snake poised to strike,' // 'Your eyes where nothing is revealed / Of bitter or sweet, / Are two cold jewels where are mingled / Iron and gold.' // 'Where everything is gold, steel, light and diamonds / There glitters forever, like a useless star, / The frigid majesty of the sterile woman.' // 'Under your satin slippers, / Under your dear silken feet, / I place all my happiness, / My genius and my destiny.' // 'I thought I saw blended in a novel design / Antiope's haunches and the breast of a boy.' // 'My darling was naked, and knowing my heart well, / She was wearing only her sonorous jewels,' // 'Her eyes fixed upon me, like a tamed tigress, / With a vague, dreamy air she was trying poses.'

9. Hamilton, p. 79. Also Hyslop and Hyslop, pp. 111–13.

10. 'That much adorned maiden / Calm and always prepared.' Baudelaire, *Flowers of Evil*, no. cliv. The other poems cited are nos. cxxxiii, lxiv, xxiii, xxvii, respectively. 'Sed non satiata', cited further on, is translated by Aggeler as follows: 'Singular deity, brown as the nights, / Scented with the perfume of Havana and musk, / Work of some obeah, Faust of the savanna, / Witch with ebony flanks, child of black midnight.'

11. C. Baudelaire, *Petits poèmes en prose*, ed. J. Crépet, Paris, 1926, pp. 83–5; published June 1863.

12. J. Richardson, *The Courtesans*, Cleveland and New York, 1967, pp. 177–80.

13. Jamot-Wildenstein, no. 110; incorrectly dated 1864; see Tabarant, p. 57. On the Courbet, see Pichois and Ruchon, no. 11.

14. G. Raynal, *Histoire philosophique et politique des établissements et du commerce des Européens dans les deux Indes*, 3 vols., Geneva, 1775, II, pp. 406–7.

15. J. J. Virey, *Histoire naturelle du genre humain*, 3 vols., Paris, 1824, II, p. 150.

16. G. Flaubert, *Dictionnaire des idées reçues*, ed. C. Bonnefoy, Paris, 1964, s.v. 'Négresses', 'Blondes', 'Brunes'; published posthumously 1911. On the Romantic tradition, see G. Bäuer, *Le Romantisme de couleur de Chateaubriand à M. Paul Morand*, Société de Conférences . . . de Monaco, 1930, pp. 20–23.

17. Ch. 1, note 40, above. See also Charles Cordier's *Bust of a Negress*, 1861 (Louvre).

18. B. Farwell, 'Courbet's *Baigneuses* and the Rhetorical Feminine Image', *Art News Annual*, XXXVIII, 1972, pp. 65–9.

19. Wildenstein, *Ingres*, nos. 228, 237. See J. L. Connolly, Jr., 'Ingres and the Erotic Intellect', *Art News Annual*, XXXVIII, 1972, pp. 21–5.

20. Jamot-Wildenstein, nos. 54, 53, 35, respectively; the last one incorrectly dated 1860; see Sandblad, pp. 28–9, 94–6.

21. Jamot-Wildenstein, no. 81. Tabarant, p. 79. For his impressions of Brazilian Negresses in 1849, see E. Manet, *Lettres de jeunesse*, Paris, 1928, pp. 52, 58.

22. Farwell, 'Courbet's *Baigneuses*', pp. 69–70.

23. C. Blanc, *Histoire des peintres de toutes les écoles: Ecole française*, 3 vols., Paris, 1868, III, 'Xavier Sigalon', pp. 2–3. Published serially in 1862; see Ch. 2, note 13, above.

24. Ricatte, p. 67.

25. Hamilton, p. 78.

26. Ch. 1, note 15, above. J. Claretie, *Peintres et sculpteurs contemporains*, Paris, 1874, p. 204; published 1872. Fervacques (L. Duchemin) in *Le Figaro*, 25 Dec. 1873; trans. Hamilton, p. 173. Only Mallarmé observed, in 'The Impressionists and Edouard Manet', *Art Monthly Review*, I, no. 9, 1876, p. 118, that the cat 'was apparently suggested' by one of Baudelaire's prose poems, but his article remained totally unknown until very recently.

27. J.-F.-A. Ricci, *E. T. A. Hoffmann: L'Homme et l'oeuvre*, Paris, 1947, pp. 444–72.

28. For the ones cited, see *Flowers of Evil*, nos. xxxvi, xix, lxix, respectively; see also no. liv. The first two are translated by Aggeler as follows: 'When my fingers leisurely caress you, / Your head and your elastic back, / And when my hand tingles with the pleasure / Of feeling your electric body,' // 'I should have liked to live near a young giantess, / Like a voluptuous cat near the feet of a queen.'

29. Ch. 2, note 82, above. See Baudelaire, *Fleurs du mal*, pp. 411–13.

30. Curtiss, nos. 6–9, 11, 17, 20.

31. *Dictionnaire érotique moderne*, s.v. 'Chat'. J. de la Rue, *La Langue verte*, Paris, n. d. (1894), s.v. 'Chat'.

32. E. Fuchs, *Die Frau in der Karikatur*, Munich, 1907, p. 192. *Idem, Geschichte der erotischen Kunst*, 3 vols., Munich, 1912–18, II, p. 92.

33. Harris, no. 58. Champfleury (J. Fleury), *Les Chats: Histoire, moeurs, observations, anecdotes*, 5th ed., Paris, 1870, pp. 258–62. Also related to it is the etching *The Cats*; Harris, no. 64.

34. Duret, p. 165.

35. Hofmann, *Earthly Paradise*, pp. 350–51. Baudelaire, *Flowers of Evil*, nos. xvii, xxviii, lxix.

36. Drawn up June–July 1864; Baudelaire, *Correspondance*, VI, p. 96. Manet had already depicted a cat as a kind of alter ego in an etched frontispiece (Harris, no. 37), and had even been described as a cat-like person (Biez, p. 65).

37. C. Baudelaire, *Nouvelles histoires extraordinaires par Edgar Poe*, ed. J. Crépet, Paris, 1923, pp. 11–24; published 1857.

38. See Harris, p. 26, and Béraldi, no. 148. Fried, p. 71, note 88, adds the cat in Chardin's *The Skate* as another source, but unconvincingly; see Reff., 'Manet's Sources', p. 47.

39. Harris, no. 65; published in Champfleury, opposite p. 41.

40. Champfleury, pp. 132–4, including an account of Baudelaire's love of cats. Pichois and Ruchon, no. 207.

41. Harris, no. 65, cites one by Harunobu as a source, but it differs in many respects; see W. von Seidlitz, *A History of Japanese Colour-Prints*, trans. A. H. Dyer and G. Trippler, London, 1910, opposite p. 60.

42. Pichois and Ruchon, nos. 109–12.

43. ibid., nos. 115–18.

44. Letter to Poulet-Malassis, Aug. 1860; Baudelaire, *Correspondance*, III, p. 177.

45. M. T. Riley, 'Meaning in the Rose', *American Rose Annual*, Harrisburg, 1949, pp. 176–82, with bibliography of Language of Flowers, 1800–1937. J. Hecker, *Das Symbol der blauen Blume im Zusammenhang mit der Blumensymbolik der Romantik*, Jena, 1931, pp. 6–9.

46. Pichois and Ruchon, no. 124.

47. H. Augu, *Les Femmes sans nom*, Act II, Scenes 5–7; published 1867, never performed.

48. A. Dumas fils, *La Dame aux camélias*, Act I, Scene 5; written 1849, performed 1852. On the symbolism of camelias and violets in a contemporary English picture, see W. G. Robertson, 'A Note on Watts' Picture "Choosing"', *Apollo*, XXVIII, 1938, pp. 318–19.

49. Listed in S. D. Braun, *The 'Courtisane' in the French Theatre from Hugo to Becque*, Johns Hopkins Studies in Romance Literatures and Languages, Extra Vol. XXII, 1947, pp. 147–9.

50. See also the Carpeaux bust and the photographs of her; reproduced Richardson, *Courtesans*, pp. 116–17.

51. Hopp, p. 28, note 29. B. Reifenberg, *Manet*, Bern, 1947, p. 12.

52. I am indebted to Mr. Larry Pardue, Public Information Officer, New York Botanical Garden, for identifying these flowers and the one in Olympia's hair.

53. P. Zaccone, *Nouveau langage des fleurs*, Paris, 1858, pp. 94, 132. J.-J. Grandville, *Les Fleurs animées*, texts by A. Karr, *et al.*, 2 vols., Paris, 1845, I, pp. 51, 90. C. Joret, *La Rose dans l'antiquité et au moyen âge*, Paris, 1892, pp. 50–52, 56–9, 63–5.

54. Grandville, *Fleurs animées*, I, pp. 82–3.

55. Ch. 3, note 49, above.

56. Jamot-Wildenstein, no. 209. For the other still lifes cited, nos. 101, 104–6, 391–3, 504–8, etc.

57. ibid., no. 208. See Ch. 3, note 48, above.

58. P. Valéry, 'Tante Berthe' and 'Berthe Morisot', *Degas, Manet, Morisot*, trans. D. Paul, New York, 1960, pp. 122–3; published 1926 and 1941, respectively. Zaccone, pp. 112–13. Grandville, *Fleurs animées*, I, p. 51.

59. V. de Jankovitz, *Etude sur le Salon de 1865*, Besançon, 1865, p. 67. F. Deriège in *Le Siècle*, 2 June 1865; cited Tabarant, p. 108. Bazire, pp. 43–4, also identifies it as 'a red flower'.

60. R. Corson, *Fashions in Hair*, New York, 1965, pp. 528–33. Richardson, *Courtesans*, pp. 43–4, 111, 116–17, 122.

61. Ch. 3, note 52, above. In one of Manet's etchings (Harris, no. 52), the flower more nearly resembles an hibiscus.

62. Richardson, *Courtesans*, p. 57. On their cultivation in France, see *Grande dictionnaire universel du xixᵉ siècle*, s.v. 'Orchide'.

63. *Handwörterbuch des deutschen Aberglaubens*, ed. H. Bächtold-Staubli, Berlin and Leipzig, 1927–41, s.v. 'Knaubenkräuter'.

64. Letter to Poulet-Malassis, 1865; cited Pichois and Ruchon, p. 116.

65. Ch. 2, note 2, above.

66. Ch. 1, note 12, above. See also Chesneau's remarks; cited Ch. 2, note 45, above.

67. Rosenthal, pp. 123–5. Jamot, 'Manet and *Olympia*', p. 28.

68. Bodkin, p. 166. C. Hayward, *The Courtesan: The Part She Has Played in Classic and Modern Literature and Life*, London, 1926, pp. 333–4.

69. Mathey, pp. 11, 14. Jamot-Wildenstein, I, p. 29.

70. Sandblad, pp. 97–8.

71. A. Dumas fils, *La Dame aux camélias*, Paris, 1931, p. 254; also pp. 237, 241; published 1848.

72. ibid., pp. 128–9.

73. E. Augier, *Le Mariage d'Olympe*, Act I, Scene 1; performed 1855.

74. Ch. 3, note 49, above.

75. Ch. 3, note 47, above.

76. C. de Lovenjoul, *Histoire des oeuvres de H. de Balzac*, Paris, 1879, pp. 84–8. H. de Balzac, *La Comédie humaine: Etudes de moeurs: Scènes de la vie de province*, III, ed. M. Bouteron and H. Longon, Paris, 1913, pp. 144–62; published 1843–4.

77. A. Maurois, *Prometheus: The Life of Balzac*, trans. N. Denny, New York, 1966, p. 175.

78. Abbé Gualdi [G. Leti], *Une Courtisane au Vatican*, Herblay, 1950, Preface by A. Lorulot, p. 5; published 1666 as *Histoire de Donna Olimpia Maldachini*.

79. W. Stirling, *Velázquez and His Works*, London, 1855, p. 159. See also C. Justi, *Diego Velázquez and His Times*, trans. A. H. Keane, London, 1889, pp. 355–6, 362.

80. E. T. A. Hoffmann, 'L'Homme aux sables', *Contes fantastiques*, trans. H. Egmont, 4 vols., Paris, 1840, I, pp. 255–312. See G. Pankalla, 'E. T. A. Hoffmann und Frankreich', *Germanisch-Romanisch Monatsschrift*, XXVII, 1939, pp. 308–18.

81. Braun, chap. v; also pp. 147–9 for details of the plays discussed below.

82. A. Dumas fils, 'A Propos de *La Dame aux camélias*', *Théâtre complet*, 7 vols., Paris, 1868–92, I, p. 28.

83. V. Hugo, *Marion Delorme*, Act V, Scene 2; written 1829, performed 1831. See Braun, chap. i; also pp. 147–9 for details of the plays discussed below.

84. Ch. 1, note 22, above.

85. Confidential report to the Minister; cited F. A. Taylor, *The Theatre of Alexandre Dumas fils*, Oxford, 1937, p. 86.

86. Richardson, *Courtesans*, pp. 209–31. Anon., *Paris at Night: Mysteries of Paris High Life and Demi-Monde*, Paris, 1870, pp. 18–40.

87. Lithograph by Andrieux in *Le Charivari*, 14 May 1864; trans. Curtiss, p. 728.

88. Dumas fils, *Théâtre complet*, I, p. 46.

89. Kracauer, pp. 203–8. O. Gheorghiu, *Le Théâtre de Dumas fils et la société contemporaine*, Nancy, 1931, pp. 149–63.

90. E. Caro, 'Les Moeurs contemporaines au théâtre', *Revue contemporaine*, 1857; cited Braun, p. 85.

91. F. Loliée, *La Fête impériale*, Paris, n. d. [1912], p. 224.

92. ibid., pp. 129–32.

93. Ch. 3, note 86, above. Also Loliée, chap. viii.

94. Zed, pp. 36–7, 91; also the description of Adèle Courtois, p. 20.

95. Zola, *Rougon-Macquart*, II, p. 1674.

List of Illustrations

31. *The Naked Maja.* By Goya, *c.* 1800. Oil on canvas. Madrid, Prado. (Photo: Anderson-Giraudon.)

32. *The Clothed Maja.* By Goya, *c.* 1800. Oil on canvas. Madrid, Prado. (Photo: Anderson-Giraudon.)

33. *Young Woman Reclining in Spanish Costume.* By Manet, *c.* 1862. Oil on canvas, 95 × 113 cm. Yale University Art Gallery, Bequest of Stephen Clark. (Photo: Yale University Art Gallery.)

34. *Blush For Her* (*Caprichos*, Pl. 31). By Goya, 1799. Etching and aquatint. New York, Metropolitan Museum of Art, Gift of M. Knoedler & Co. (Photo: Metropolitan Museum of Art.)

35. *Reclining Woman.* By Manet, 1862–3. Ink, 13.5 × 19 cm. Collection unknown. (Photo: Columbia University Library.)

36. *Reclining Prostitute.* By Constantin Guys, 1850–60. Woodcut reproduction in G. Geffroy, *Constantin Guys*, 1904. (Photo: Columbia University Library.)

37. *Odalisque.* By Manet, 1862–3. Ink, watercolor, and gouache, 12.7 × 19.7 cm. Paris, Louvre. (Photo: Archives Photographiques.)

38. *Odalisque.* By Delacroix, 1847. Lithographic reproduction in *L'Artiste*, 1847. (Photo: the author.)

39. *Nude Woman with Black Cat.* By Manet, 1862–3. Ink, 21 × 27.5 cm. Collection unknown. (Photo: Bibliothèque Nationale.)

40. *Nude Woman with Black Cat.* By Manet, 1862–3. Sepia and watercolor, 28.5 × 41 cm. Collection unknown. (Photo: M. Knoedler & Co.)

41. *Faithful.* By Léon Noel, 1831. Lithograph. Paris, Bibliothèque Nationale. (Photo: Bibliothèque Nationale.)

42. *I Was Lazy.* By J.-J. Grandville, 1842. Woodcut in *Scènes de la vie privée et publique des animaux.* (Photo: Columbia University Library.)

43. Study for *Olympia.* By Manet, 1862–3. Sanguine, 24.5 × 45.7 cm. Paris, Louvre. (Photo: Bulloz.)

44. Study for *Large Odalisque.* By Ingres, 1813–14. Pencil. Paris, Louvre. (Photo: Giraudon.)

45. *Large Odalisque.* By Ingres, 1814. Oil on canvas. Paris, Louvre. (Photo: Giraudon.)

46. *The Modern Courtesan.* By Thomas Couture, 1873. Oil on canvas. Pennsylvania Academy of the Fine Arts. (Photo: Pennsylvania Academy.)

47. *Olympia.* By Manet, 1862–3. Watercolor, 20 × 31 cm. Paris, Collection Stavros S. Niarchos. (Photo: A. C. Cooper.)

48. *Odalisque.* By Eugène Durieu, 1854. Photograph. Rochester, George Eastman House. (Photo: George Eastman House.)

49. *Odalisque.* By Manet, 1868. Etching and aquatint, 12 × 19.1 cm. Middletown, Davison Art Center. (Photo: E. Irving Blomstrann.)

50. *The Lady with the Fans.* By Manet, 1873. Oil on canvas, 113.5 × 166.5 cm. Paris, Musée de l'Impressionnisme. (Photo: Archives Photographiques.)

51. Caricature of the Empress Eugénie. By Paul Hadol, 1871. Colored lithograph. London, Victoria and Albert Museum. (Photo: Victoria and Albert Museum.)

52. *Nana.* By Manet, 1877. Oil on canvas, 150 × 116 cm. Hamburg, Kunsthalle. (Photo: Bulloz.)

53. *The Negress.* By Manet, 1862–3. Oil on canvas, 59 × 49 cm. Turin, Private Collection. (Photo: Réunion des Musées Nationaux.)

54. *The Young Courtesan.* By Xavier Sigalon, 1822. Oil on canvas. Paris, Louvre. (Photo: Réunion des Musées Nationaux.)

55. Detail of *Olympia.* (Photo: Agraci.)

56. *In the Boudoir.* By an unidentified German artist, 1860. Lithograph. (Photo: Columbia University Library.)

57. *The Cats' Rendezvous.* By Manet, 1868. Lithograph, 43.5 × 33 cm. Paris, Bibliothèque Nationale. (Photo: Bibliothèque Nationale.)

58. Illustration of Poe's *Black Cat.* By Alphonse Legros, 1861. Etching. Paris, Bibliothèque Nationale. (Photo: Bibliothèque Nationale.)

59. *Cat and Flowers.* By Manet, 1869. Etching and aquatint, 16.5 × 12.7 cm. Paris, Bibliothèque Nationale. (Photo: Bibliothèque Nationale.)

60. Detail of *Olympia.* (Photo: Agraci.)

61. Title-page of Marguerite Bellanger's *Confessions*, 1862. London, British Museum. (Photo: British Museum.)

62. *Bunch of Violets.* By Manet, 1872. Oil on canvas, 21 × 27 cm. Paris, Private collection. (Photo: Giraudon.)

63. Detail of *Olympia.* (Photo: Agraci.)

64. *Cora Pearl.* By Anatole Pougnet, *c.* 1860. Photograph. Paris, Collection Sirot. (Photo: Columbia University Library.)

65. '*What Difference is There . . .*' By Auguste Andrieux, 1864. Lithograph. Cambridge, Harvard University Library. (Photo: Harvard University Library.)

Index

Bold numbers refer to illustration numbers